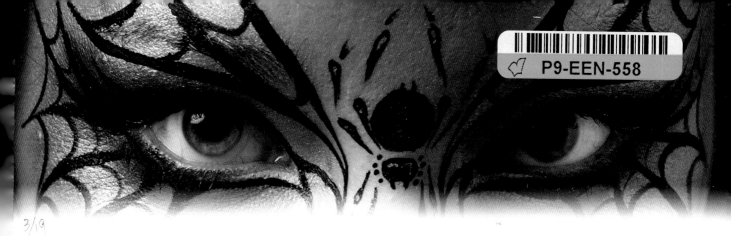

3/19

EXTREME
Costume Makeup

25 CREEPY & COOL step-by-step demos

Brian & Nick WOLFE

IMPACT

CINCINNATI, OHIO
www.impact-books.com

contents

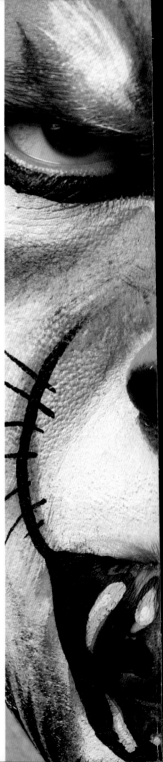

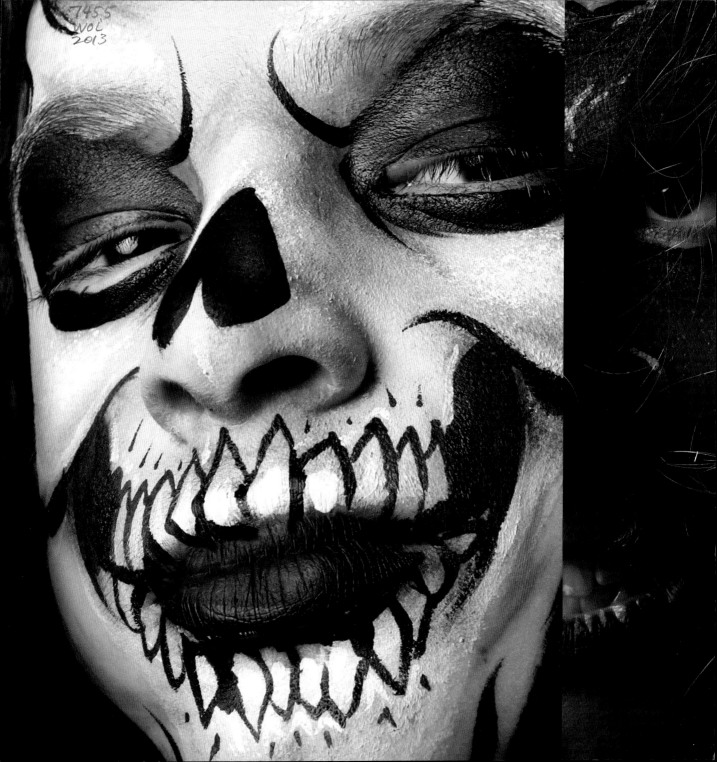

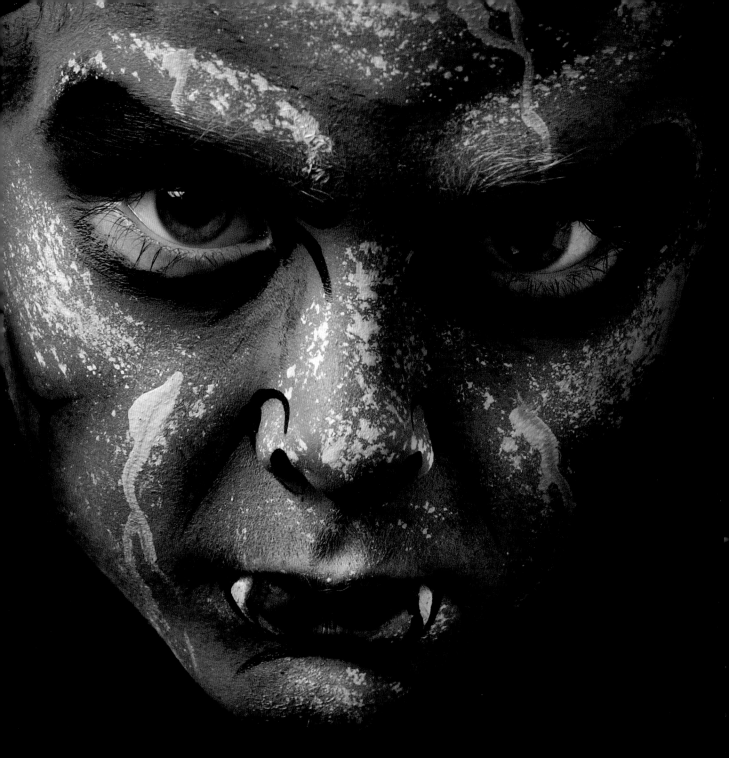

sometimes it's good to be BAD.

Everyone has a dark side—sometimes lurking just beneath the surface, sometimes locked deep within. To express this side of ourselves creates wholeness, though many of us conceal it from others most of the time. Haven't you ever wanted to wear yours proudly—to let it LOOSE?

Fiendish faces like the ones in this book—from gruesome and freakish to mysterious and otherworldly—are some of the most entertaining faces to paint.

Face painting is an art form that has no boundaries and is as original as the face that is painted. It is two-dimensional art put on a three-dimensional canvas that moves, roars or maniacally laughs. People who get painted act differently than they ever have before. They do more than wear the paint on their faces and the costumes on their bodies. They become that witch or that zombie. They are transformed.

So, lose the mask, grab some face paints, and unleash your inner baddie! Even if only until the paint fades.

Materials

You don't need a ton of stuff to get started painting faces. Brushes and paints are the essentials.

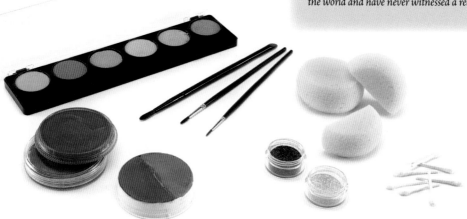

Paints

Use water-based theatrical makeup that is hypoallergenic and non-toxic. Acrylic paint is not made for face painting and should be avoided. Every brand of face paint works. Some have more pigment and brighter colors, while some are easier to wash off. Decide which characteristic is more important to you and go with that.

Brushes

We use small synthetic rounds. Make sure they have stiff bristles with sharp points that can yield a fine line. Stick with a no. 3 round for ideal control. The bigger the brush, the less control you'll have, which means the lighter your touch will need to be. A no. 3 round allows you to make a really thin line, and, by applying more pressure, you can produce a wide line as well. If you find your line-work is a bit heavy-handed, try a no. 1 round. Use a no. 6 round for very wide lines. All these brushes can be found in any art or craft store.

Other Materials

Cotton swabs cut in half are useful as disposable applicators, erasers (when used with a little water) or disposable brushes. You'll also need sponges. We recommend firm sponges with rounded edges and large pores. The sponges used for this book are pottery sponges cut in half. Hand sanitizer, baby wipes and loose polyester glitter are also great items for your kit.

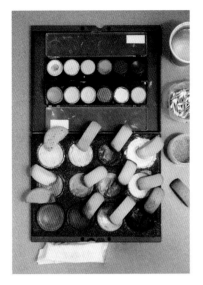

Face Painting Kit Setup

All face painting kits are unique, but this is our typical setup. One color per sponge is recommended. Use one end for the paint and keep one end dry for blending.

Split Paint Cakes

Split cakes have both the dark and light shades of a color. Some have one half UV-reactive (black light) paint. The idea is to have more color choices in a smaller kit and to be able to mix colors to achieve maximum coverage and the brightest color. Colors can be mixed right on top of the cake as well. Wipe the cake clean with a baby wipe to get it back to the original condition.

Using Sponges

Wet only the very tip of the sponge. The amount of water determines how much paint there will be to work with. If you wipe a sponge across the cake a few times, the makeup will be thin, watery and transparent. Rub the sponge many times and the makeup becomes thick and opaque.

Color Wheel

Make yourself a simple color wheel to help you choose colors. Colors on the same side of the color wheel blend easily—for instance, yellow, orange and red. Yellow is often used to highlight because it is brighter. To paint a green ball, for example, use blue for shade and yellow to highlight.

Another way to change the value of the base color is to add black (for shade) or white (for highlight). You can also create highlights by adding white to an adjacent color on the wheel. For example, to highlight purple, use light blue or light red.

Sponge Techniques

The sponge is used to cover the face quickly with thin amounts of paint. Twisting the sponge in different directions can really add detail. Always test a sponge first to see how wet the paint is that's on it. It may have plenty of paint and water from the last face you painted. The sponge is a very versatile tool, so don't be afraid to use it a lot. Practice and pay attention to what you do and what the results are.

STIPPLING

This is one of the most useful sponge techniques. Stippling is great for blending color, suggesting texture, indicating highlights and suggesting facial hair. To get the most realistic result, hold your half sponge upside down so the rounded part touches the skin. Using the edge of the sponge would result in lines— something you want to avoid when stippling.

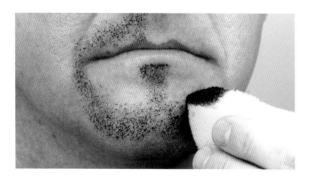

Stippling to Suggest Facial Hair
Lightly tap the sponge in an even pattern.

Making Circular Strokes
To make a circular stroke with your sponge, simply apply the end of the sponge to the face and spin.

CIRCULAR STROKES

Circular strokes can be used for cheek art and sectioning off parts of the face. A rounded sponge is perfect for this. The sponging doesn't have to be perfect; just try to make it as close as possible. The edges can be corrected with a brush later.

FUR TECHNIQUE

Use the fur technique to create striation patterns not only for fur textures, but also for muscle patterns and creature textures. If executed correctly, you can create a lot of detail quickly.

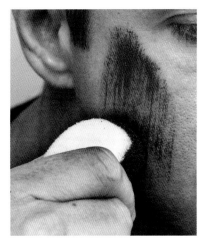
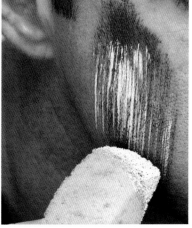

Creating Fur

Fill your sponge with paint, then pull it in a downward motion across the face. Then, go back in with a second color, lightly dragging your sponge over the basecoat to indicate more texture.

Adding Dots

Make dots with the corner of your sponge.

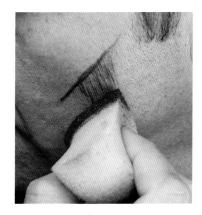

Painting Line Strokes

Use the edge of your sponge to place line strokes.

Dragging Color

Pull color by dragging with the end of your sponge out from the paint.

Blending Color

Blend colors with the clean end of your sponge.

Download a FREE bonus demo at impact-books.com/extreme-costume-makeup.

9

Brush Techniques

When painting lines, pretend your brush is dancing. The more fluid and confident your brushstrokes are, the more pleasing the design will be. Practice your linework often. Use your arm or thigh to warm up on and try new techniques. Hold the brush like a pencil and close to the end for more control. Sometimes, it helps to use your pinky finger to steady your hand. Nice linework can really save sloppy sponge work.

Remember, he who paints most, paints best. To become a quick and accurate painter, practice and focus!

PAINTING THIN TO THICK TO THIN LINES

Using a thin to thick to thin line gives your face paintings style and depth, not to mention they will look fancier.

DRAWING STARS

Add stars to your face paintings to give extra flare or excitement. Whether painting a five-pointed star or a starburst, creating the perfect shape is all in the wrist. Simply flick your brush lightly, stroke by stroke, to create any star shape you desire.

1 Begin Thin to Thick

Begin the brushstroke before your brush meets the skin. Then, gently touch the tip of your brush to the face, gradually applying more pressure toward mid-stroke.

2 Finish Thick to Thin

Once the thickest part of the line has been laid in, slowly begin picking your brush up off the skin as you move toward the end of the stroke.

HOW TO REMOVE PAINT

To remove face paint, use any of these items:
- *cold cream*
- *lotion*
- *baby shampoo*
- *baby oil*
- *baby wipes*

Massage any of these into the face, then wipe it off immediately. Use eye makeup remover to get off any paint placed around the eyes.

DRAWING STARS

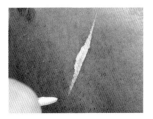

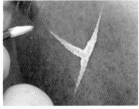

1 Begin the Star
Place your brush on what will be the center point of the star and flick a line down.

2 Add the Second Stroke
Flick your brush to the left.

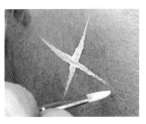

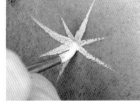

3 Place the Third Stroke
Next, flick your brush to the right to form a cross.

4 Develop the Star
Fill in your star with more small flicks radiating from the center.

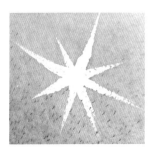

5 The Finished Result
By beginning in the center and working out, your stars will look as though they are bursting and exploding with energy.

PAINTING SWIRLS AND CURLS

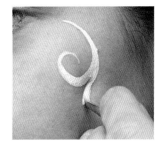

1 Begin Swirls and Curls
Press your brush down toward the face when drawing the thickest part of your swirl or curl.

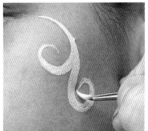

2 Finish Swirls and Curls
Conversely, apply barely any pressure at all when drawing the thinnest part.

PAINTING RAINDROPS AND TEARDROPS

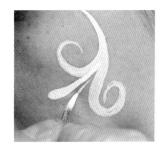

1 Begin Raindrops and Teardrops
Create the thin point of the drop, applying light pressure with the tip of your brush.

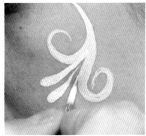

2 Finish Raindrops and Teardrops
Gradually increase pressure and flatten the brush as you move toward the thicker end of the drop.

Download a FREE bonus demo at impact-books.com/extreme-costume-makeup.

11

PAINTING EYES

The design of the eyes is the most important part of the look of the characters you paint. Is your dragon supposed to be scary or cute? It all depends on the eyes. They are what everyone will look at first.

Your hand or arm is a good place to practice your painting.

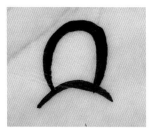

1 Begin a Cute Eye
Draw a small arch to indicate the cheek. Place a larger arch above the small one to suggest the eye. Connect the end to the small arch.

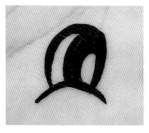

2 Build a Cute Eye
Add a thick half arch inside the eye for the iris.

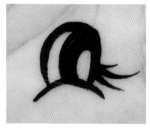

3 Add Cute Eyelashes
Add three thick-to-thin strokes at the corner of the eye to lay in the eyelashes.

4 Finish a Cute Eye
Add white highlights to the cheek and the whites of the eye.

1 Begin a Mean Eye
Paint a sideways S-shape for the eyebrow.

2 Build a Mean Eye
Add an almond-shaped eye beneath the brow.

3 Shade the Eyebrow
Add shadows beneath the brow and the eye.

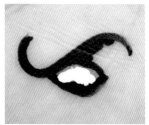

4 Finish a Mean Eye
Fill in the eye with white.

Cotton Swab Techniques

Inexpensive and disposable, cotton swabs are valuable tools to have around.

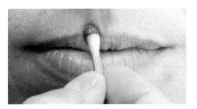

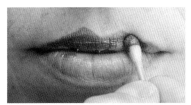

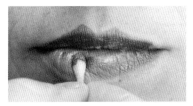

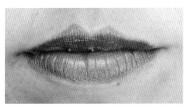

Applying Paint to Lips
Using a cotton swab on lips is less ticklish and gives the artist a more sanitary approach than using a brush. After the lips are painted, you can throw away the swab.

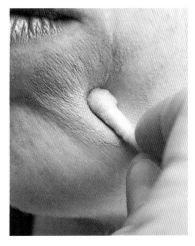

Erasing Mistakes
There really isn't any erasing in face painting. "Mistakes" are integrated into the design—using glitter for girls and blood for boys. If you need to clean up edges or lift out some color, dip a cotton swab in water and apply it to the spot. To clean up drips, however, wipe the skin with a moist towelette or tissue.

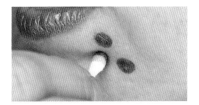

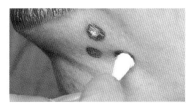

Laying In Dots
Dots made with a swab tend to be more consistent. If you need your dots to be the same size (like the rivets on a helmet), definitely use a cotton swab.

CUTS AND BLEMISHES
If a model has any cuts or blemishes, use a cotton swab to paint around the wound without contaminating your brush or sponges. Bad sunburn, eczema, chicken pox sores and cold sores, etc., should always be avoided as the makeup may irritate the skin further.

Here are a few more techniques good to have in your repertoire as you begin painting faces.

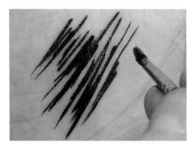

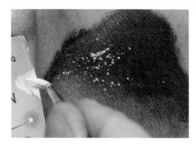

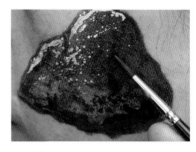

Mottling

Mottling is painting random squiggles and dots to break up a smooth paint job and make something appear more textured. We use this a lot with zombie skin and monsters. It adds dimension and detail. Use the side of your brush to add wiggly strokes for mottling in texture. The brush shouldn't be too wet and the paint should be thinned.

Creating Fur Texture

To suggest fur using your brush, flick the brush back and forth using the thin to thick to thin line technique. Paint in short, quick strokes for the best results. This is the technique used for moustaches, beards and animal fur.

Spattering

Spattering can be used for texture on rocks, for stars in outer space, as freckles, or as blood spraying from a wound. Using your brush, flick paint from a card aimed at the area you want to spatter.

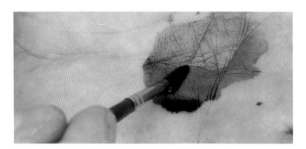

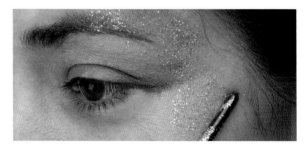

Applying a Wash

Place a dab of paint in your palm, then water it down to create a thin consistency. Washes work well for shadowing beneath objects, making them pop off the face.

Applying Glitter

Dip the end of a round brush in glitter and roll it onto wet paint.

SHADING AND OUTLINING

Shading and outlining are the basic painting skills that are good
to master as you paint the projects. Practice with a simple sphere.

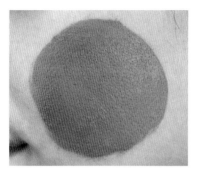

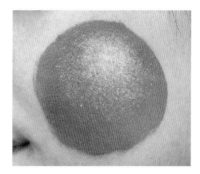

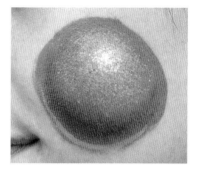

1 Establish the Basic Shape
Apply a basecoat in the shape of the
object you wish to portray.

2 Add Highlight for Dimension
Apply the highlight thickly in one
small spot. Then stipple the color out
from the bright center, overlapping
the highlight.

3 Place Shadows and Highlights
Apply a darker shade toward the bot-
tom of the sphere, leaving a little line
of the midtone to represent reflected
color. Then, apply white to the very
center of the yellow highlight, and
add a white highlight on the reflected
color at the bottom of the sphere.

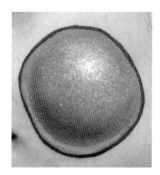

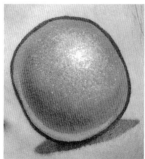

4 Outline the Shape
Outline the sphere using a brush. When outlining, don't
look at the tip of your brush. Rather, look at the object you
are outlining and let your eye trace the outside. Your brush
will automatically follow your eye.

When you finish a stroke but need to keep the outline
going, don't start a new stroke at the end of the finished
stroke. Instead, overlap the strokes so the line is consistent.

Adding a dark shadow underneath the sphere makes it
appear to be resting on a surface.

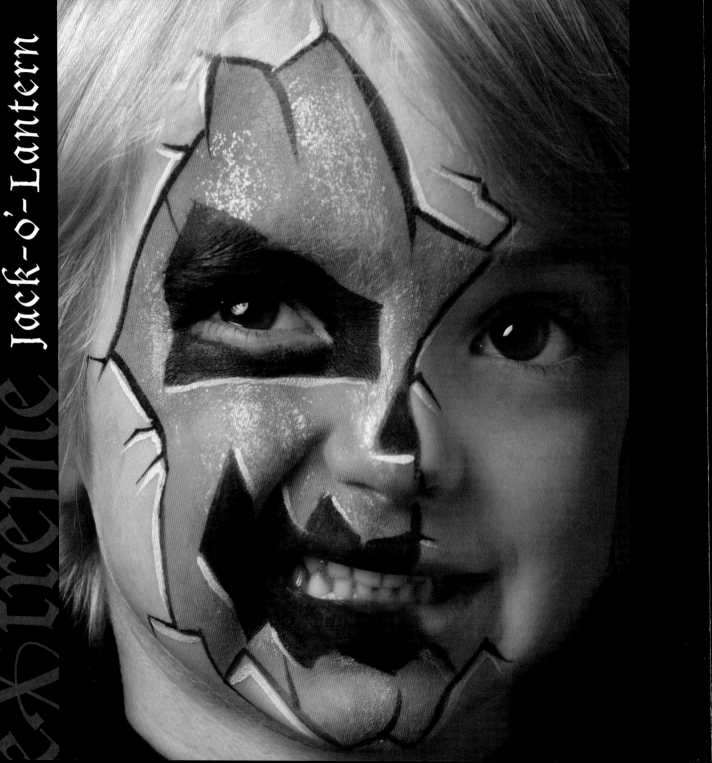

Extreme

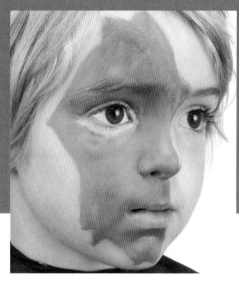

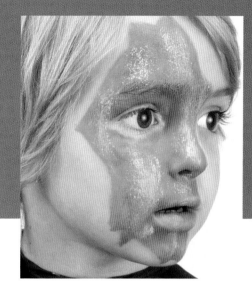

1 Apply an orange basecoat across the right half of the face, using a sponge to lay in a somewhat jagged geometric shape.

2 Use a sponge to stipple on yellow over the orange basecoat to indicate texture and add dimension.

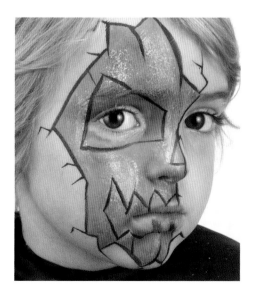

3 Outline the orange with black using a no. 3 round. Also outline the eye and suggest the teeth. Then, paint the grooves and cracks on the edges of the pumpkin face using the same brush and color.

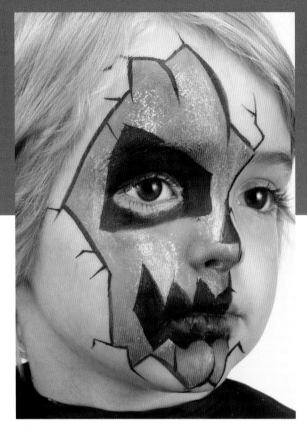

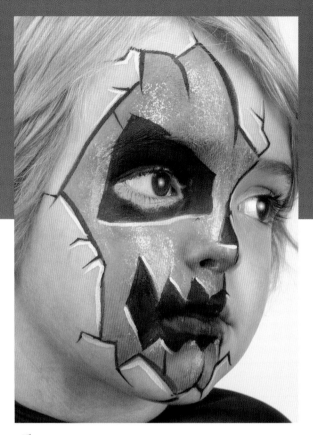

4 Fill in the eye with black using a sponge. Then, using a no. 3 round loaded with black, clean up the edges of the eye and fill in the nose and mouth.

5 Add white highlights around the features and cracks using a no. 3 round.

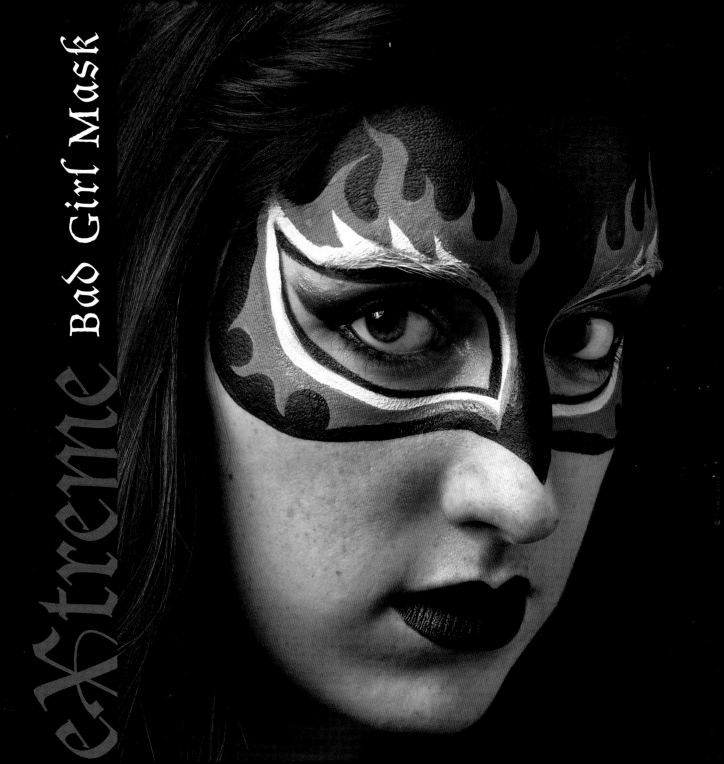

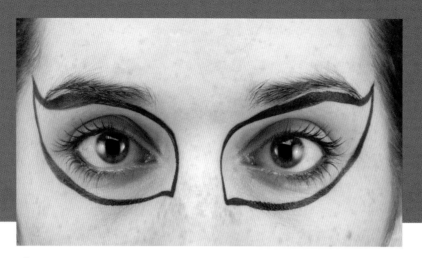

1 Using a no. 3 round, carefully outline the eye holes of the mask with black, keeping them as symmetrical as possible.

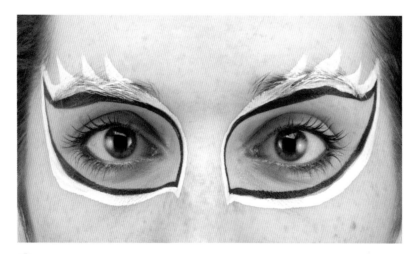

2 With the same brush, outline the eye holes with white, adding spiky flares radiating from the top of the eyes and crossing the brow.

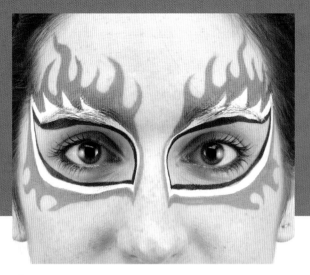

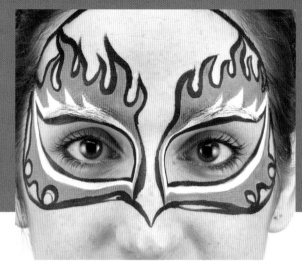

3 Outline the white border around the eyes using a no. 3 round and a mixture of neon pink and purple. Paint around the spikes and add a flame pattern as you go.

4 Using a no. 3 round, outline the edges of the purple flames with black. Then, add the outline for the mask, working from the center of the nose, up around the forehead and down the opposite side of the face.

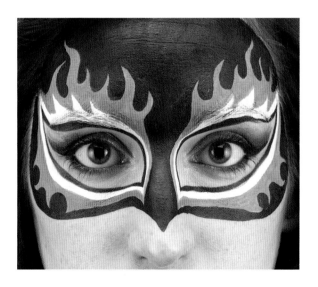

5 Using a no. 6 round, fill in the mask and lips with black. With the same brush, add metallic purple eye shadow across the eyelids. Line the eyes with black and the no. 3 round.

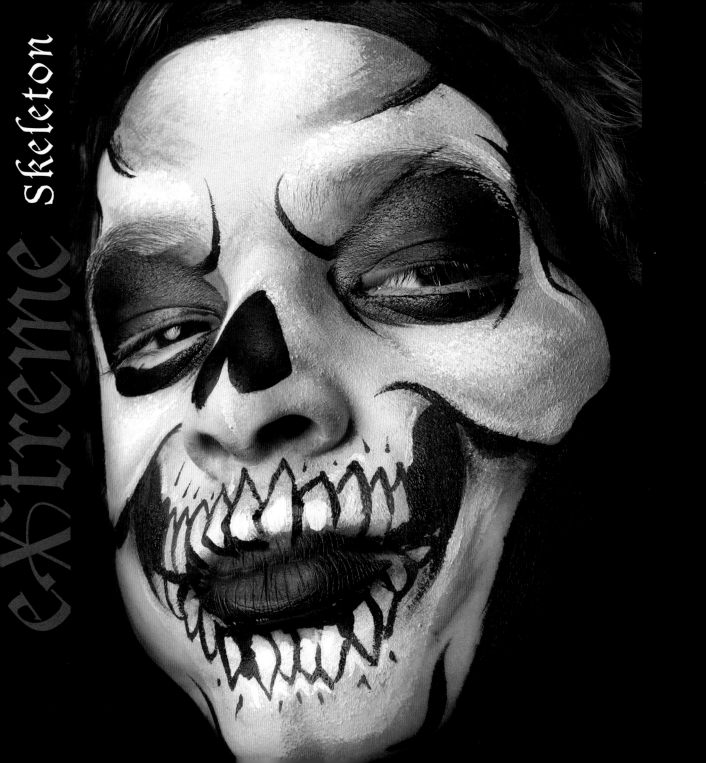

1 Using a sponge, apply an off-white basecoat on the forehead, cheeks and jaw, painting around the nasal cavity.

2 Shade the skull with brown along the inside of the eyes, on the forehead, and around the mouth and chin using a sponge. Then, highlight the edges of the nose, cheeks, forehead and chin using a sponge and white.

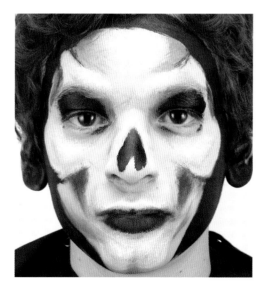

3 Using a sponge, outline the face with a thick black line, carving in the skull shape. Also shade the cheeks and fill in the nasal cavity, lips and eyelids using the same color.

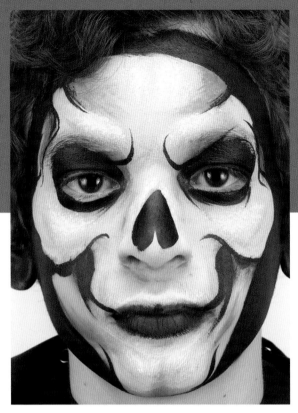

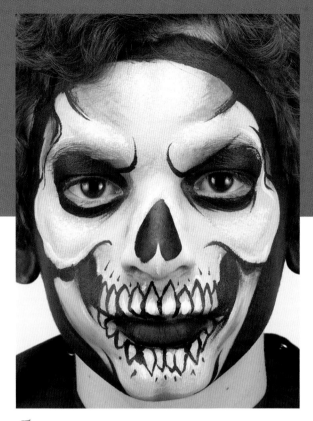

4 Outline and add more details to the skeleton face. Clean up edges to make them crisp using a no. 3 round and black.

5 Continue detailing the face with a no. 3 round and outline the teeth. This is for an open-mouthed skeleton, so be sure to keep the teeth fully visible. Use white to fill in the teeth and highlight the bones, placing thin lines next to the darkest areas.

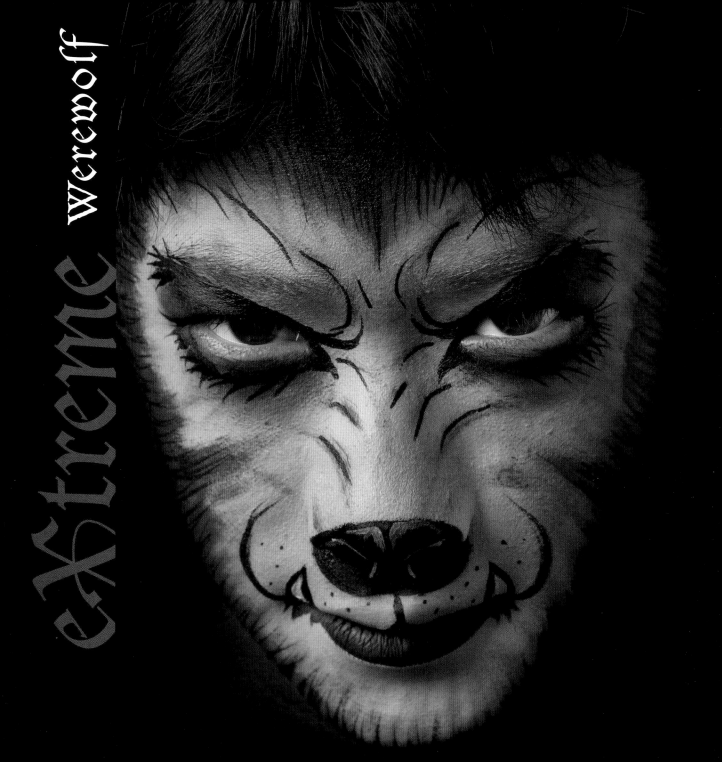

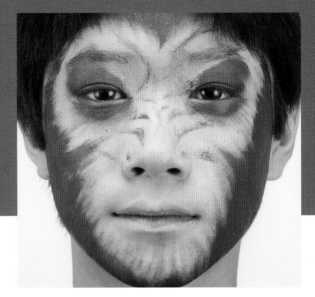

1 Working in a heart shape, apply a basecoat of goldenrod to the face using a sponge.

2 Add brown on the eyelids with a sponge and drag it out a bit to blend and create the appearance of fur. Apply the same color around the outer edge of the face, again dragging the sponge to suggest fur. Use the edge of the sponge to add the brow and nose wrinkles and shade under the eyes.

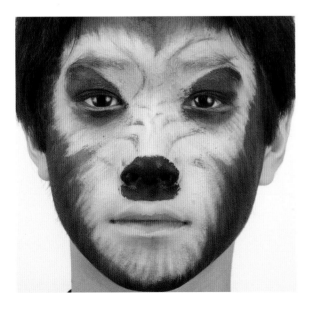

3 Using a sponge, apply black fur strokes right over the brown at the outer edge of the face. Use the edge of the sponge to fill in the brows, then paint the werewolf's nose on the tip of the actual nose as well as beneath it to extend the nasal cavity and create the illusion of a snout.

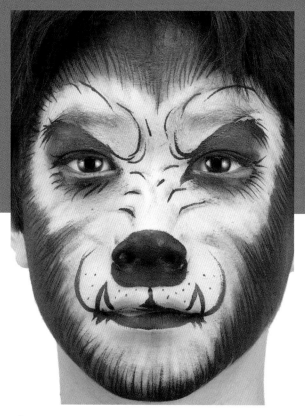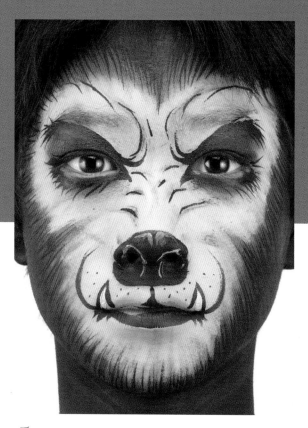

4 Paint the fur using a no. 3 round and black, dragging the brush from the outside in toward the face. Define the wrinkles, teeth and nose with thin linework.

5 Whiten the teeth and add highlights to the nose using a no. 3 round. Black in the ears and neck with a sponge to complete the look.

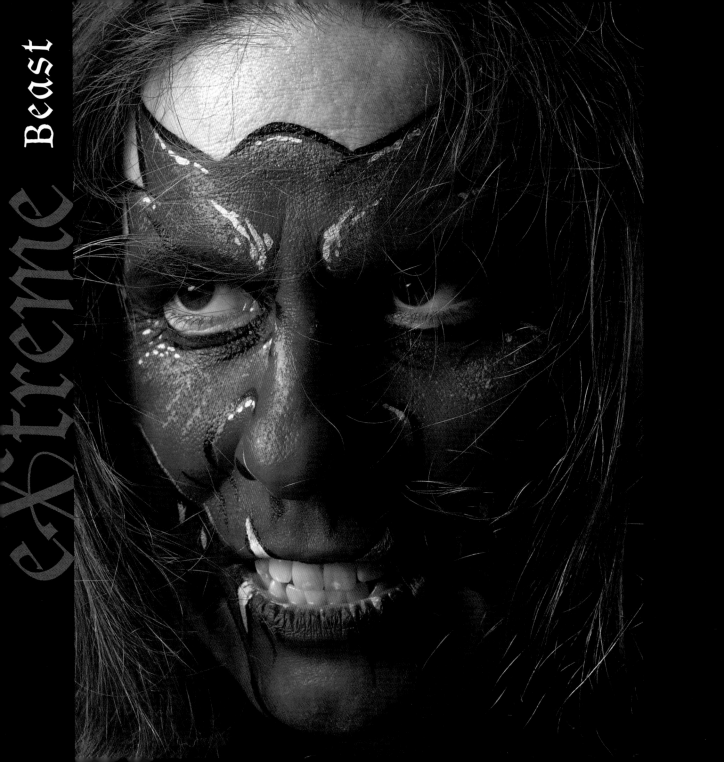

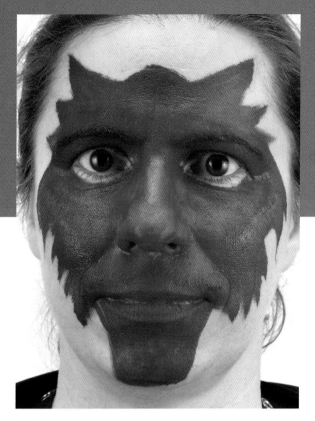

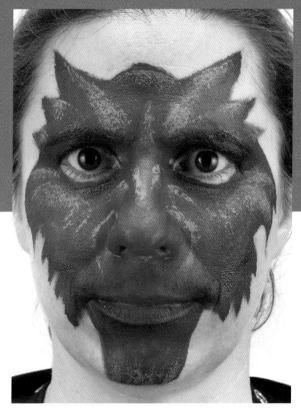

1 Apply a red basecoat to the face with a sponge, using the edge to keep the outside lines crisp. Paint from the center of the face outward, radiating toward the spikes of fur on the outer edges.

2 Stipple on tan with the corner of the sponge to highlight the fur and accent the cheekbones. Flip the sponge to the clean side to blend in as needed. Then, add brown to shade beneath the eyes, lower lip, jaw and horns.

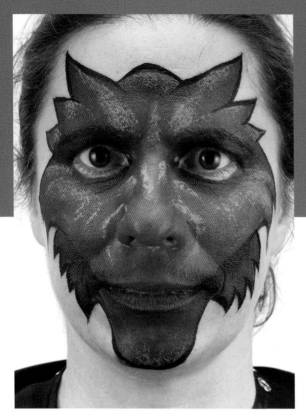

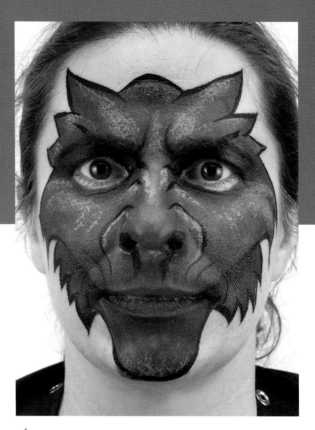

3 Darken the areas around the eyes and mouth using a sponge loaded with black. Then, outline the entire face in black using a no. 3 round.

4 Define the eyebrows and add thin black lines using a no. 3 round to suggest the wrinkles on the bridge of the nose. Use the same brush and color to establish the nose shape and fill in the nostrils.

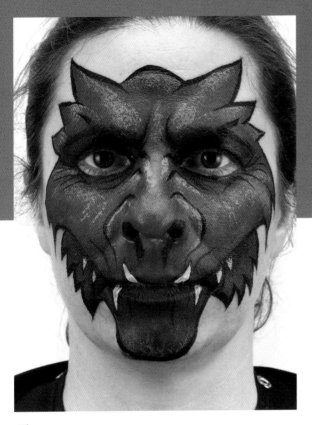

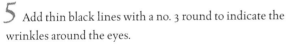

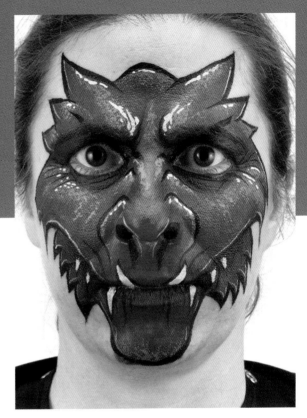

5 Add thin black lines with a no. 3 round to indicate the wrinkles around the eyes.

With the same brush and color, add outlines of teeth and drippy lines from the mouth. Then, paint in the teeth with white.

6 With a no. 3 round and white, place highlights on top of the tan highlights, painting in broken strokes. Add a thin white line underneath the top jaw to separate it from the bottom jaw. Add off-white highlights on top of some of the white highlighted areas to create more depth.

Arlene

1 Load a sponge with off-white and stroke on bandage shapes. Use the dry end of the sponge as needed to lift color if the bandages get too thick or run into one another too much.

2 Load a sponge with brown and fill in the space around the eyes, the nose and select areas around the chin to suggest skin showing through.

3 Continue to develop the skin showing through the gaps in the bandages using the edge of the sponge and brown. As the color continues to dry on the sponge, use it to lightly graze over the bandages to give them an aged appearance.

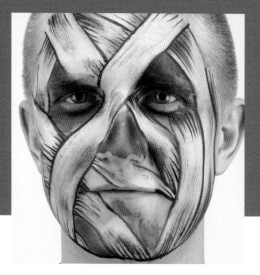

4 Apply black in the corners of the eyes and on the nasal cavities using a dry sponging technique. Also, dirty up the bandages to give them dimension, stroking on the color in the same direction as the bandages.

5 Using a no. 3 round and black, outline the bandages, weaving them over and under each other.

Place thin black detail lines on the bandages where they overlap and intersect to emphasize their direction.

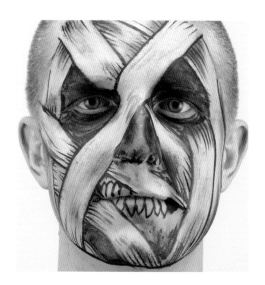

6 Use the side of a no. 3 round to fill in and mottle the eye area and add wrinkles. Add outlines of the teeth with the tip of the same brush. Place similar brushstrokes on other areas on the face to give the skin more texture.

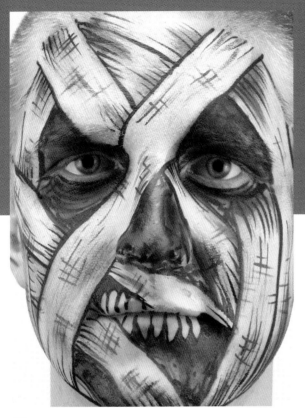

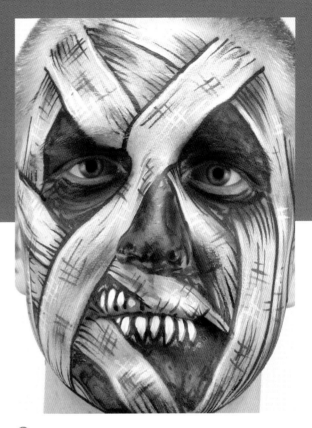

7 Use dark brown and a no. 3 round to add crosshatch marks on the bandages. Then, using the same brush loaded with dark red, rough in the gum line.

8 Add white highlights to the teeth and some of the black outlines along the bandages using a no. 3 round. For added texture, place white crosshatch marks on the bandages in areas devoid of black crosshatch marks. Add subtle white highlights to the gums using the same brush.

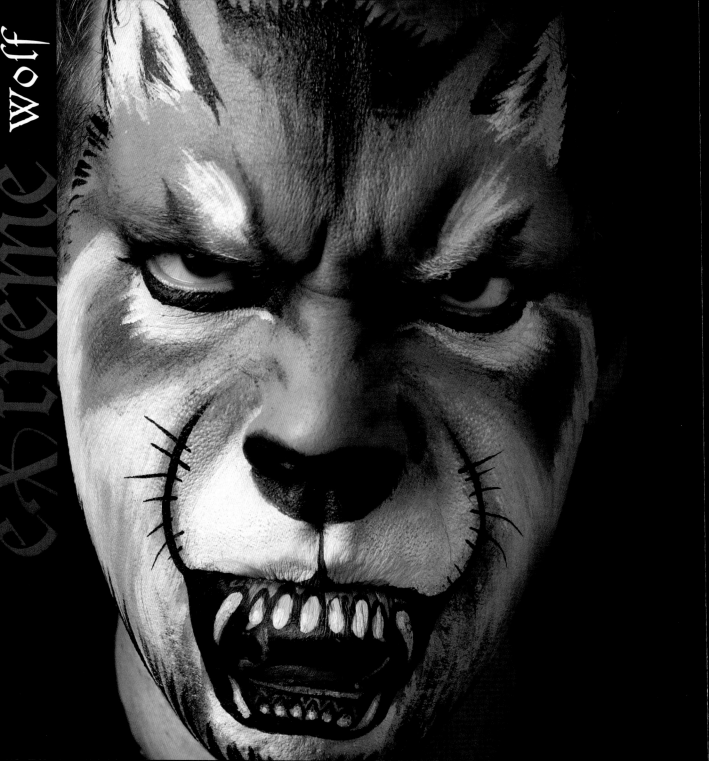

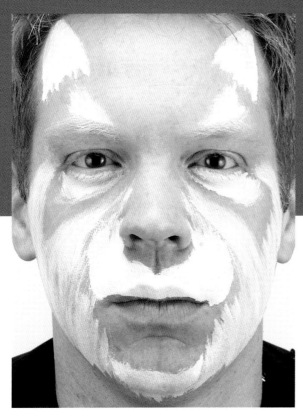

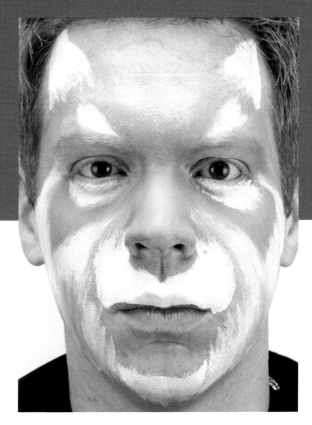

1 Apply a white basecoat around the mouth, under the eyes and on the forehead (to suggest the wolf's ears) using a sponge. Also stroke on white along the cheeks and jawline to indicate fur.

2 Sponge on gray in the negative spaces between the white, making sure you leave the areas beneath the mouth and nose free of color. Lightly dab gray over the white base on the cheeks and jaw to suggest the texture of fur.

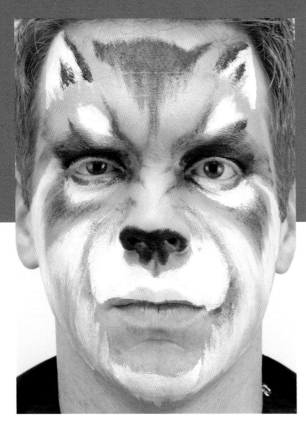

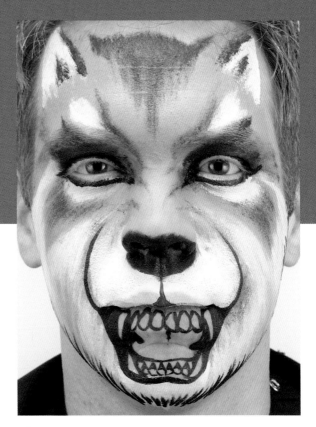

3 Shadow the face with black using a sponge. Add a fair amount of paint over the tops of the eyes, onto the brow, inside the ears and on the nostrils under the nose, as these should be the darkest areas. Then, go in lightly with dabs of black on the cheeks and ears to create fur accents.

4 Use a no. 3 round and black to clean up the nose and to paint in the outlines of teeth. Place the top teeth along the bottom lip and the bottom teeth on the chin.

Continue to add details with a no. 3 round, partially filling in the mouth with black, leaving a space for the tongue. Then, line and shape the eyes and muzzle, and stroke in black fur around the jawline.

38

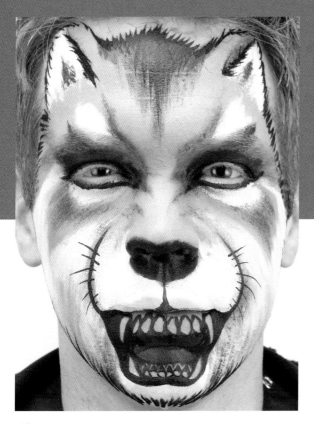
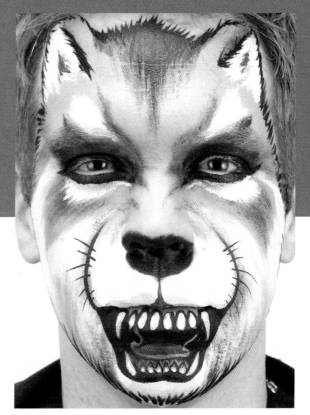

5 Finish the outline around the face, adding furry strokes of black with a no. 3 round. Define the ears and add thin whiskers along the edges of the muzzle using the same brush and color.

Fill in the tongue and gum line with a no. 3 round and some red. Then, go back in with your sponge loaded with black to shade the chin and eyes.

6 Color in the teeth using a no. 3 round and off-white. Line the eyes with black and apply some black mascara.

Add white highlights on the ears and teeth, and around the eyes with a no. 3 round.

eXtreme Zombie

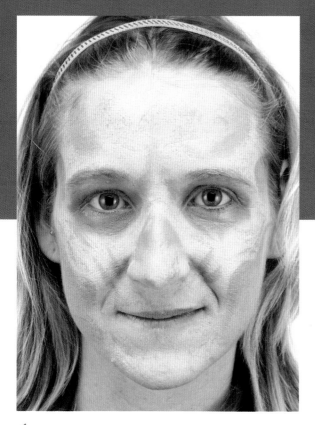

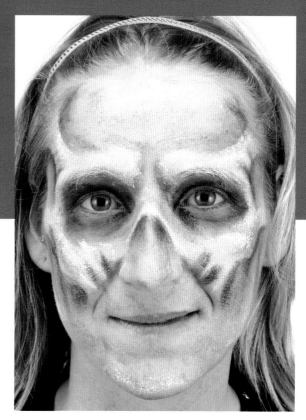

1 Apply a light flesh tone basecoat to the face using a sponge, first stroking on color and then stippling and dabbing to fill it in.

Use a sponge loaded with gray to create the skeletal form of the face. Shadow areas to sink them in and stipple a mottled pattern all over the face to break it up.

2 Deepen the shadows with black, applying color with the edge of a sponge in the darkest areas, then drag it down to blend.

Use the edge of a sponge to apply white highlights along the brim of the nose to make the nose bone pop. Then, stipple white along the brow and cheekbones for added effect.

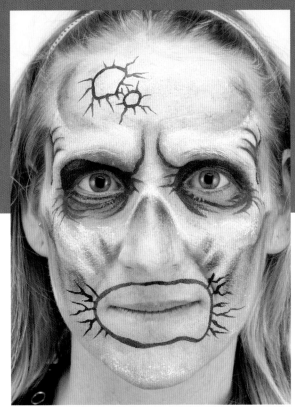

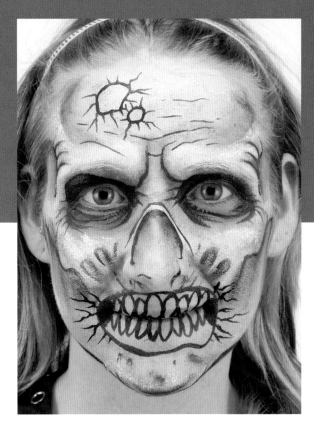

3 Use a no. 3 round and some black to outline the mouth to show where the lips have receded and cracked, and add two circles on the head to indicate wounds. Darken in the eyes, adding bags and wrinkles, using the same brush and color. Use the same technique to add wrinkles to the temples and brow line.

4 Using a no. 3 round, add black linework to the nasal cavity to help recede the area further. Sink in the muscles on the cheeks and cheekbones with teardrop shapes, and add some wrinkle lines on the forehead. Finally, outline the jaw area and add teeth.

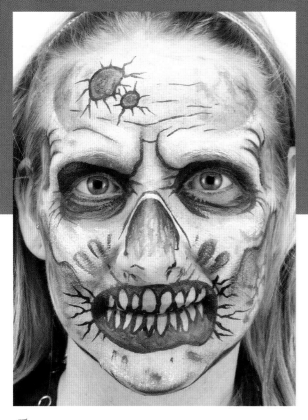

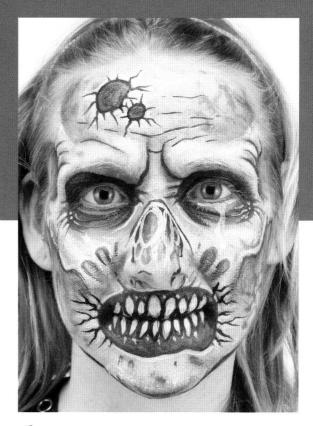

5 Use the side of a damp no. 3 round to mottle in the area surrounding the jaw and to drag color into the holes on the forehead.

Mix black with red and fill in the holes on the forehead and nose, inside the eyes and the gum area with a no. 3 round.

6 Highlight the teeth and gums and around the mouth using a no. 3 round and white. Highlight the rest of the face structure with a light flesh tone, ensuring that the highlights don't get too bright.

Add a gooey eye drip using white and a no. 3 round.

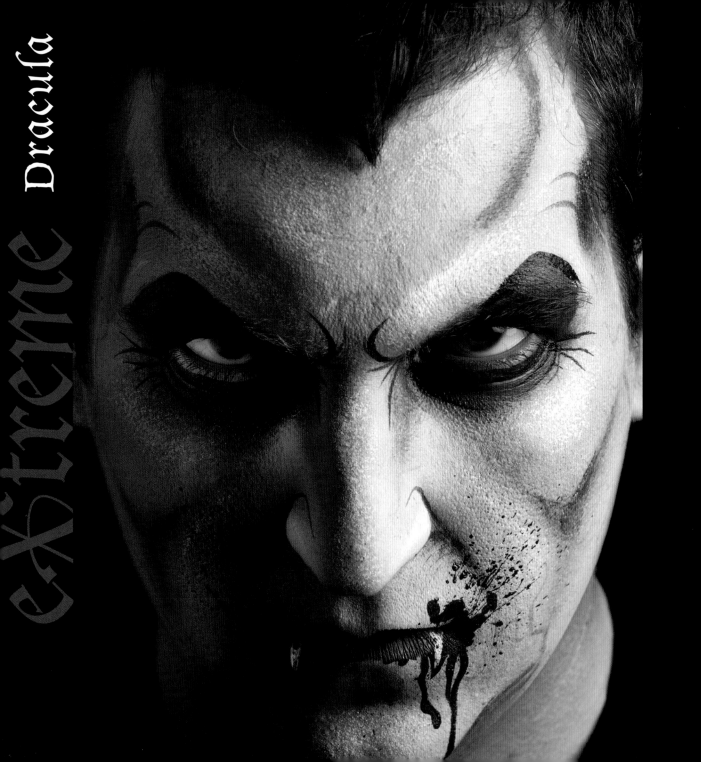

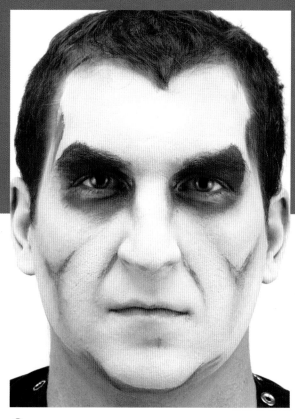

1 Apply off-white to the face using a sponge. Then, immediately stipple the basecoat with the other side of the sponge to get the color as smooth and even as possible.

2 Mix purple and brown on a sponge to make a bruisy color. Apply this mixture around the eyes and mouth and along the cheeks. While the color is still wet, use the clean side of the sponge to drag it down, creating a more subtle effect. Shade the temples using the same materials and technique.

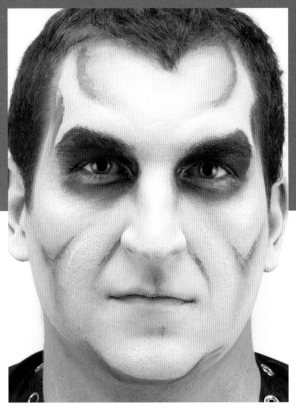

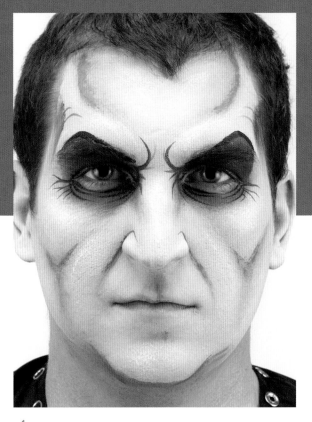

3 Shade the frontal ridge of the forehead and the divot over the lip with same color and sponge used in step 2. Then stipple in white highlights around the dark areas to add more dimension to the face.

4 Add deep shading in the corners of the eyes and on the eyelids using a sponge loaded with black.

Define the eyebrows and add thin lines under and around the eyes to suggest deep wrinkles using a no. 3 round and black.

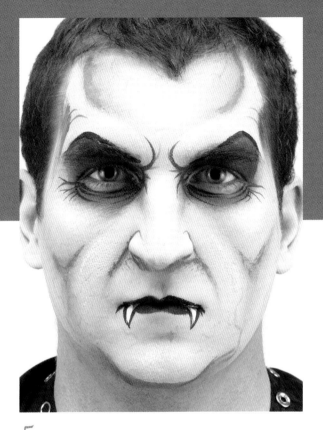

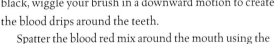

5 Paint the outline of fangs and the lips using a no. 3 round and black, then fill in the fangs with white. With the same brush and a mix of dark blue, apply thin, nearly transparent veins over the face.

Further define the nose shadow with a sponge and the bruisy color from step 2.

6 Using a no. 3 round and red mixed with a trace of black, wiggle your brush in a downward motion to create the blood drips around the teeth.

Spatter the blood red mix around the mouth using the card trick.

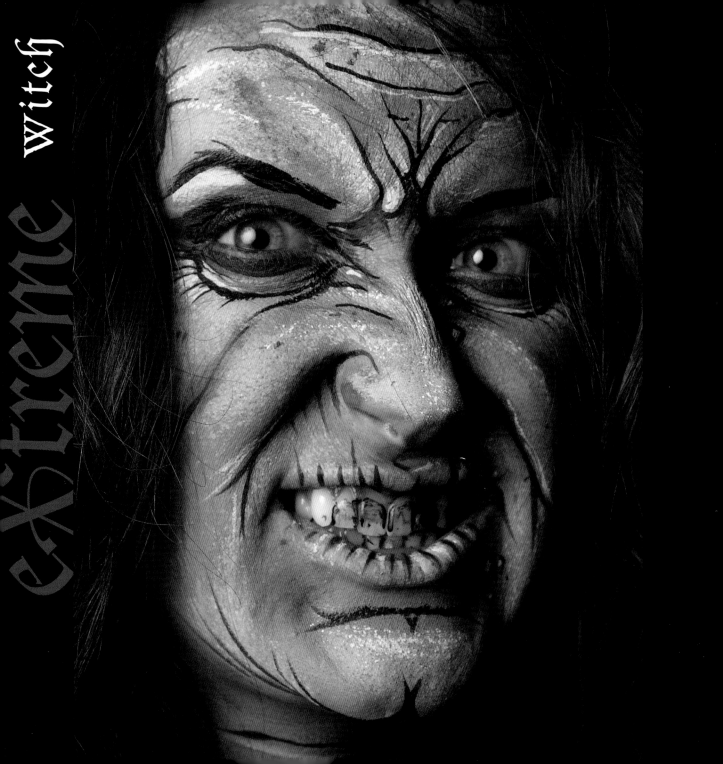

 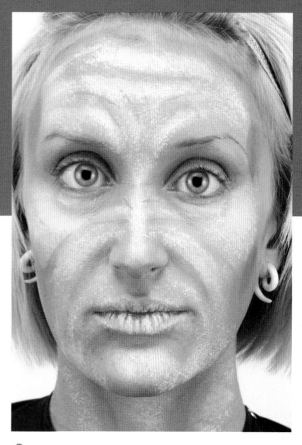

1 Apply a basecoat of pink to the face and neck using a sponge. Place off-white highlights on top of the pink with a sponge, stippling to suggest wrinkles on the forehead, cheeks and chin, and between the eyes. Apply off-white over the lips to create cracked lips.

2 Using a sponge and brown, shade in the areas between the highlights and sink in the eyes.

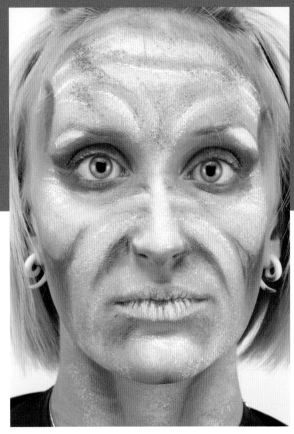

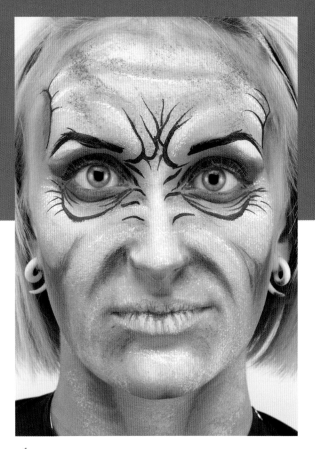

3 Stipple on white highlights along the brow, the tops of the wrinkles, and the tops of the cheekbones using a sponge. Also apply a mixture of purple and brown to deepen the shadows. Use the same color to add additional texture on the forehead with a sponge.

4 Begin detailing the face with a no. 3 round, adding black eyebrows and deep wrinkles around the eyes and bridge of the nose.

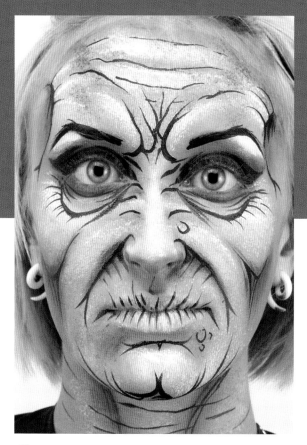

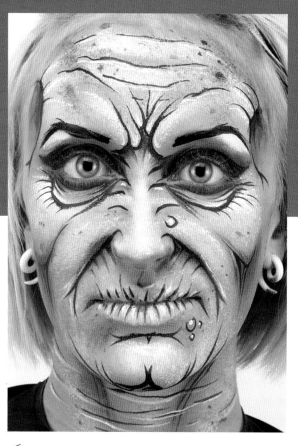

5 Using a no. 3 round and black, wrinkle the lips, cheeks, chin and laugh lines with thin strokes. Add warts with scallop shapes, and place long horizontal lines on the throat to suggest neck wrinkles. Further develop wrinkles around the eyes using the same brush and color.

6 Add white highlights along the thin wrinkles on the face and neck using a no. 3 round. Use the same brush to add liver spots and freckles on the face with the purple and brown mixture.

eXtreme

Mr. Hyde

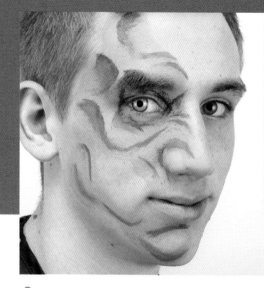

1 Apply a teal basecoat to the right side of the face with the corner of a sponge, first stroking on color and then stippling to achieve an opaque layer. Leave an unpainted area where the snarl will appear.

2 Mix dark green and blue to create a shadow color. Sponge the color onto the temple and around the eye, nose and chin areas. Use the edge of the sponge to lay in thin shapes, and use the clean side of the sponge to blend and soften.

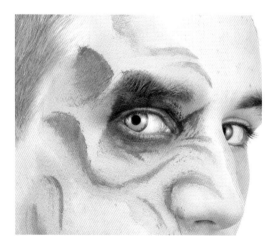

3 Sponge purple around the eye to deepen the socket. Also add a little purple to the darkest shadows on the temple and around the nose.

Download a FREE bonus demo at impact-books.com/extreme-costume-makeup.

53

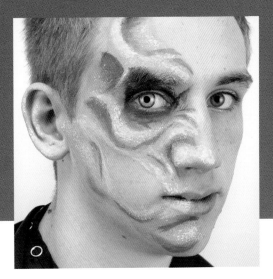

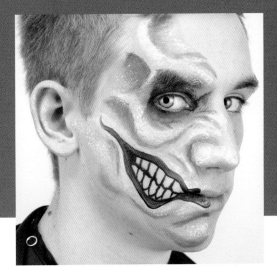

4 Sponge on some teal mixed with white to add highlights to the facial features and indicate texture. Add a little yellow on top of the white to make the highlights pop.

5 Outline the snarl in red and add a red line under the eye using a no. 3 round. Add a thin black line to the inside of the snarl using the same brush.

Suggest the teeth, outlining them in black with a no. 3 round. Fill in the space between the top teeth and bottom teeth using the same brush and color.

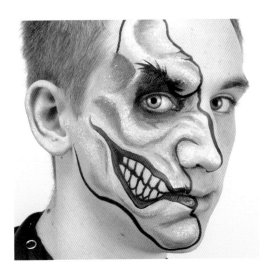

6 Outline the face with a thin black line using a no. 3 round, coming up around the forehead, down the nose and lips, and back around the chin. Add the eyebrow with the same brush and color, using short thin strokes radiating up from the model's natural brow.

54

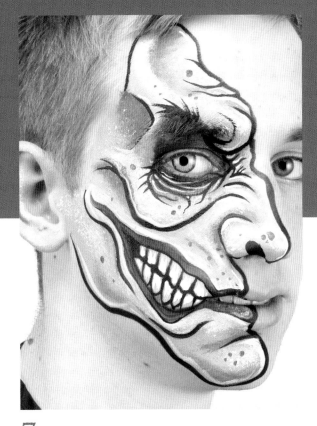

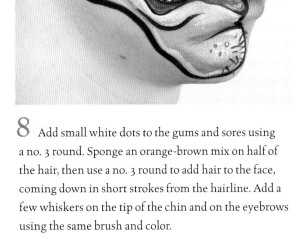

7 Use a no. 3 round and black to add wrinkles to the face. With the same brush, color in the top half of the teeth with white. Also place white highlights along the black outlines you added in the previous step.

Still using a no. 3 round, paint the gum line hot pink and add some festering sores to the face.

8 Add small white dots to the gums and sores using a no. 3 round. Sponge an orange-brown mix on half of the hair, then use a no. 3 round to add hair to the face, coming down in short strokes from the hairline. Add a few whiskers on the tip of the chin and on the eyebrows using the same brush and color.

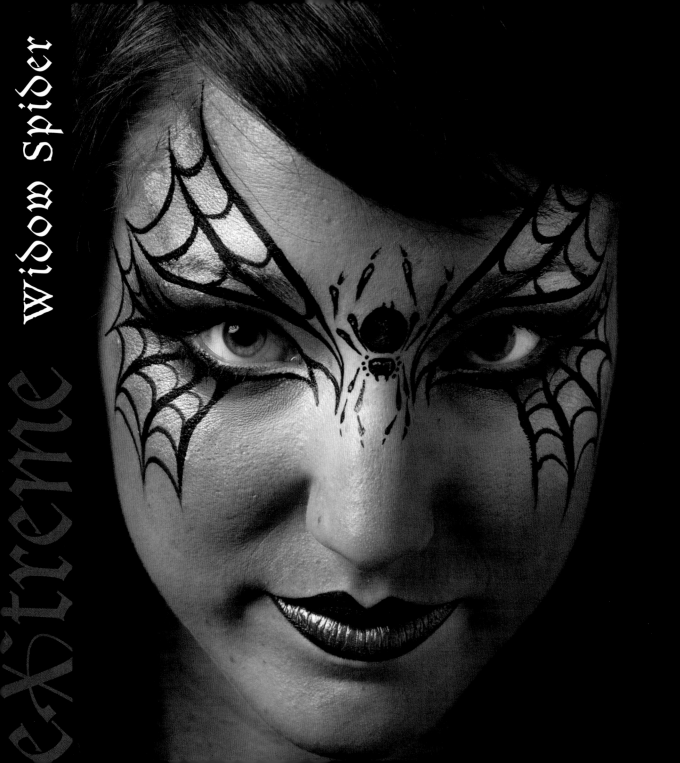

1 Apply a silver basecoat across the eyes with a sponge, creating two wing-like shapes.

2 Apply metallic purple around the eyes using a sponge. Stipple to blend the color into the silver and drag the sponge through the basecoat to begin defining the web. Shade the lids of the eyes with black, working the color into the creases. Use the clean side of the sponge to blend the black into the purple.

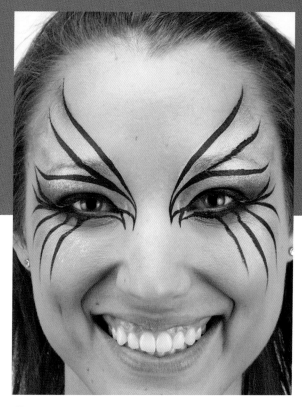 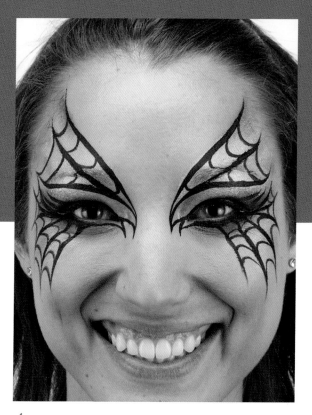

3 Begin the outline of the web design using a no. 3 round and black. Start with the lines above the eyes, pulling your brush from the inside out toward the edge of the face. Then add the linework beneath the eyes, pulling your brush in a downward motion.

4 Finish the web outline using the same brush and color. Connect the existing lines together, adding short curved strokes between the lines to create a webbed pattern. Notice these strokes curve in an upward motion above the eye, while they curve in a downward motion beneath the eye.

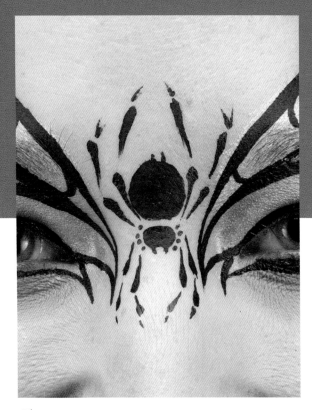

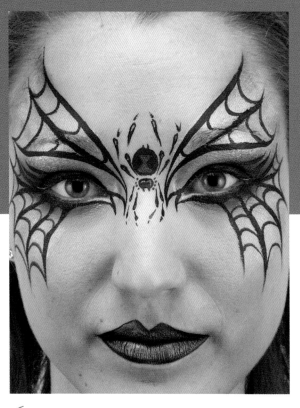

5 Use a no. 3 round and black to paint the spider's head and body between the eyes. Add four dots on each side of the thorax, then add the spider legs as a series of teardrop shapes.

6 Add a red hourglass to the body of the spider for extra effect using a no. 3 round.

Outline the lips in black, then fill them in with metallic purple using a no. 3 round.

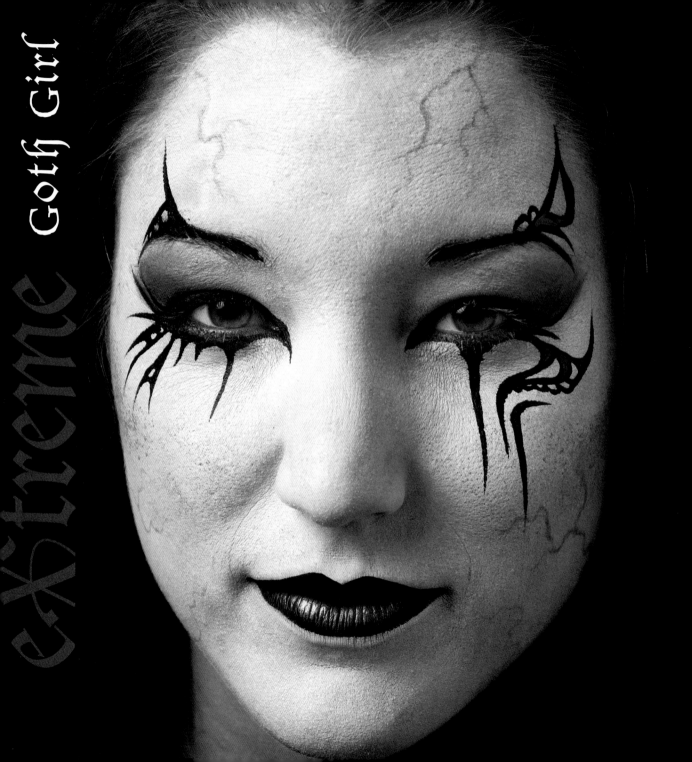

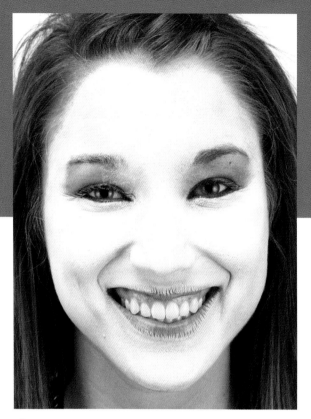

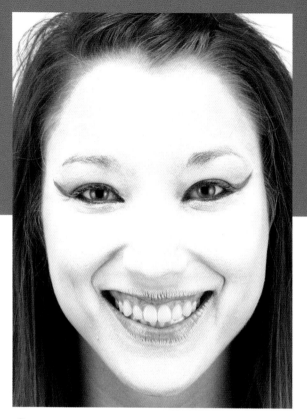

1 Apply a white basecoat to the face using a sponge, first stroking and then stippling on the color to fill evenly.

2 Cover the eyes with powder blue using a sponge. Work with the clean side of the sponge to blend the color into the white. Apply metallic blue closest to the eye, extending past the corner of the eyes and curling upward.

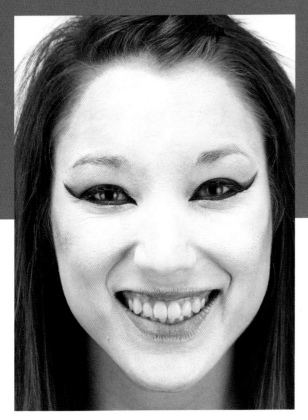

3 Stipple gray blush on the cheekbones with a sponge. Then, using a no. 3 round, line both eyes with black.

4 Add thin eyebrows and drawn on lashes using a no. 3 round and black.

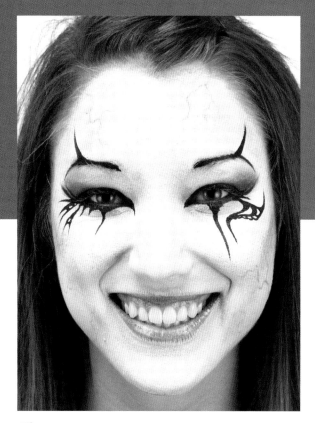 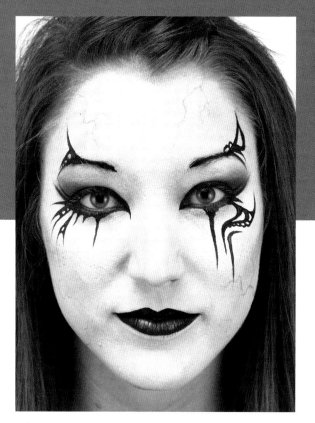

5 Using a no. 3 round, develop the linework beneath the eyes, following the contour of the cheekbones. With the same brush, darken the corners of the lids with dark blue and add thin blue lines on the face to indicate veins.

6 Continue developing the linework around the eyes, and add linework above the eyebrows using a no. 3 round and black.

Fill in the lips with black using a no. 3 round, then add metallic blue stripes down the lips to make them pop.

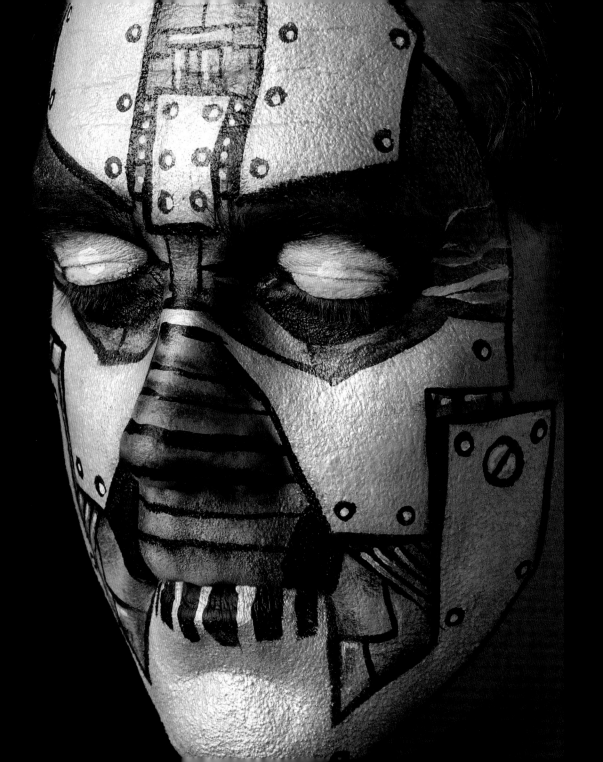

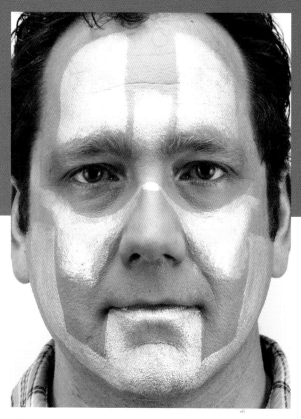

1 Apply a gray basecoat to the entire face, first stroking on color and then stippling to fill in and achieve an opaque effect. Leave some area around the eyes free from paint.

2 Stipple on silver plates, using the edge of the sponge for the thinner areas.

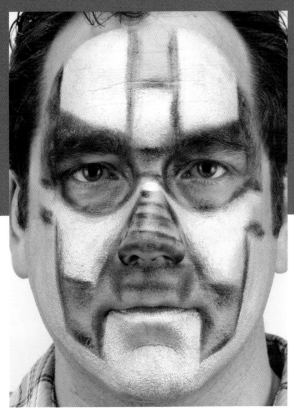

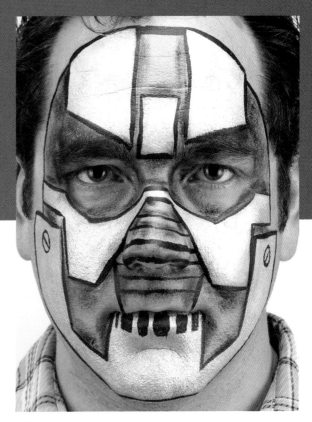

3 Shadow in the areas around the plates with black using the edge of the sponge. Also enlarge the eye sockets to give them distinct shapes.

4 Use a no. 3 round to outline the silver plates with black. With the same brush and color, begin developing the facial features. Horizontal lines help hide the nose. Screws along the jawline suggest a hinge.

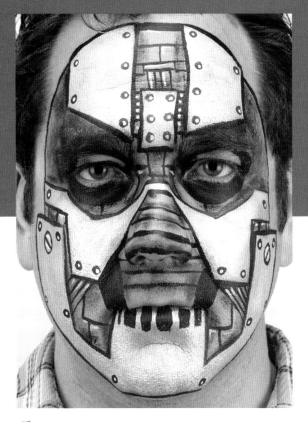 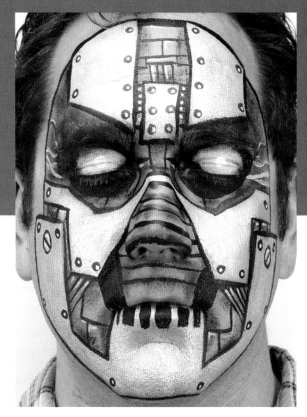

5 Add more mechanics to the forehead and more black around the eyes with a no. 3 round. Develop the darks with more shapes, and use a cotton swab to add rivets around the plates.

Add white highlights on top of the rivets and within the mechanics using a no. 3 round.

Sponge on hints of white along the outside of the eyes and on the lids as a basecoat for the next step.

6 Add blue, red and yellow wires around the eyes using a no. 3 round. It's OK if some of the white basecoat shows through—it will look like highlights.

Mix light green with neon yellow and apply it to the eyelids using a sponge. To finish, use a no. 3 round to add white highlights on the lids.

eXtreme

Alien

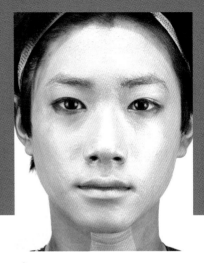

1 Mix silver with light green and apply it to the face and center of the neck using a sponge.

2 Outline and shape the alien head using a sponge and black. Create a background around the head and neck to make them appear thinner.

3 Use a sponge to add black to the eyelids and to shade the cheekbones.

4 Use a no. 3 round and black to clean up the eyes and the outline around the face and neck, and then add a very thin, short lip line. Use a sponge and black to shade under the face at the top of the neck. Spatter white stars on the background with a card, defining them a bit with a brush.

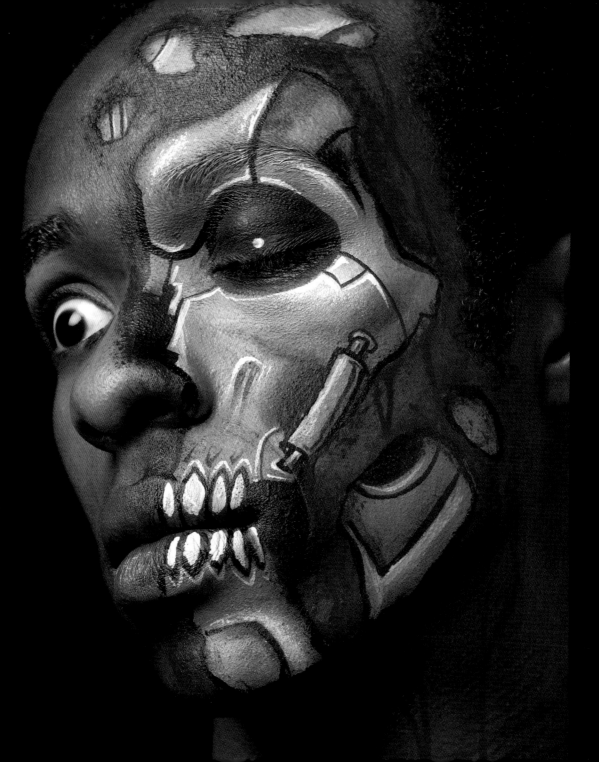

eXtreme Cyborg

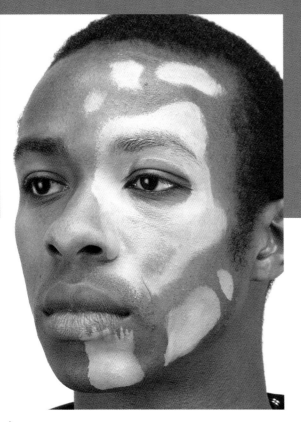

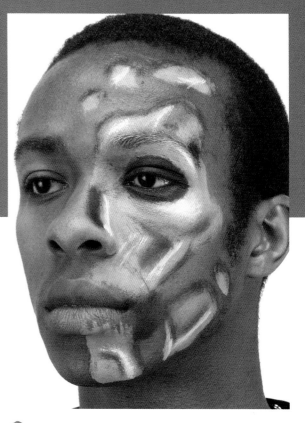

1 Use a sponge to stipple on gray, suggesting exposed metal around the left eye and in select spots along the forehead, cheek, jaw and chin.

2 Add a black circle around the eye using a sponge. As the color dries on the sponge, shade above all the metal panels to make them look like they are sunken under the skin. Shade along the nose cavity.

Stipple on white highlights along the brow and cheekbone. Use the edge of the sponge to add highlights along the metal plates.

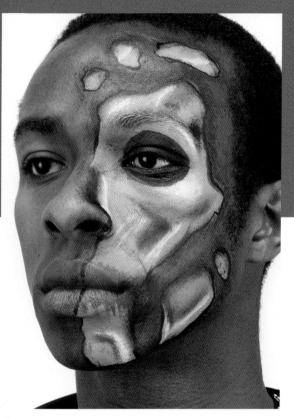 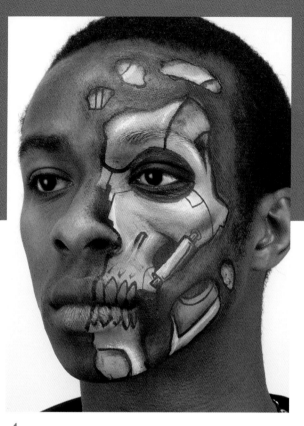

3 With a sponge, stipple on red around the plates to indicate wounds where the flesh has come away from the face.

Use a no. 3 round to clean up the eye hole edges and to outline the plates with black.

4 Use a no. 3 round and black to establish the mechanical pieces connecting the plates within the face and to add an outline of teeth.

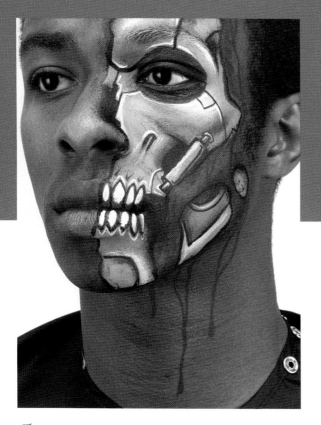

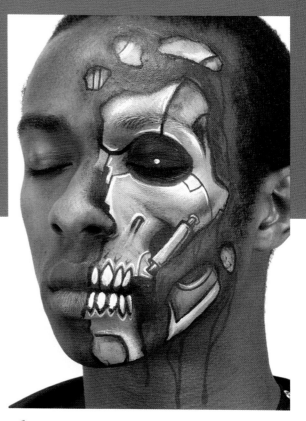

5 Fill in the teeth with off-white using a no. 3 round. Then add white highlights along one side of the black plate outlines.

Using the same brush, add red blood drips, moving your brush in wobbly lines.

6 To create the cyborg's eye, place a large red dot on the left eyelid using a no. 3 round. Once this dries, add a small, sharp white point to suggest the pupil.

Download a FREE bonus demo at impact-books.com/extreme-costume-makeup.

73

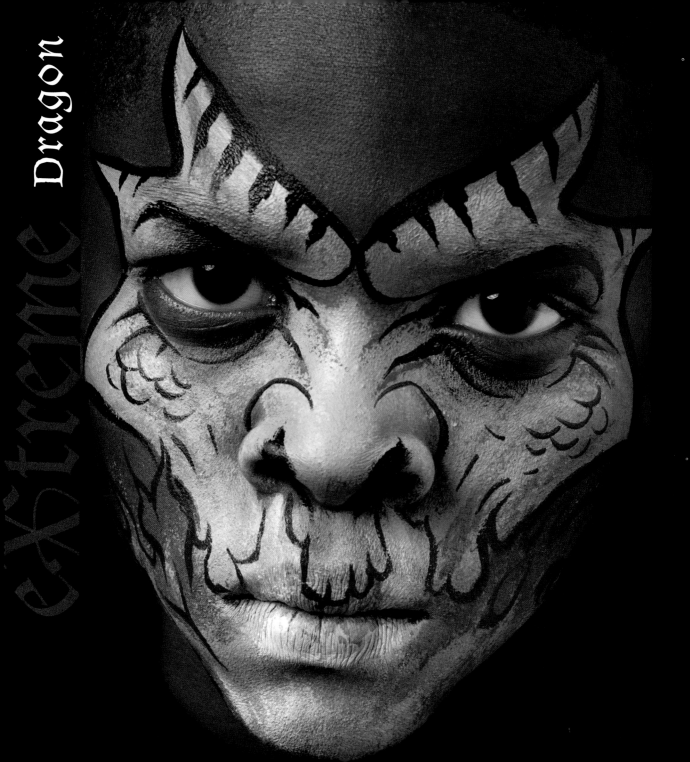

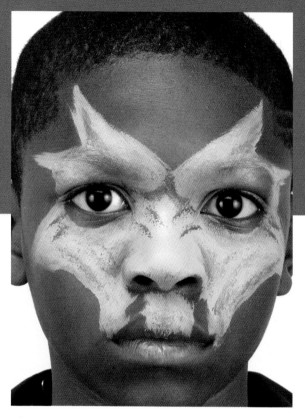

1 Using your sponge, apply a light green basecoat in the shape of a dragon face. Stipple in color to fill the shape evenly. Use a moist tissue to clean up around the edges if necessary.

2 Shade around the eyes using a sponge and dark green. Use the edge of the sponge loaded with dark green to add wrinkles around the eyes and nose.

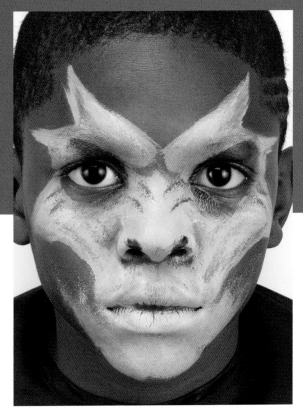 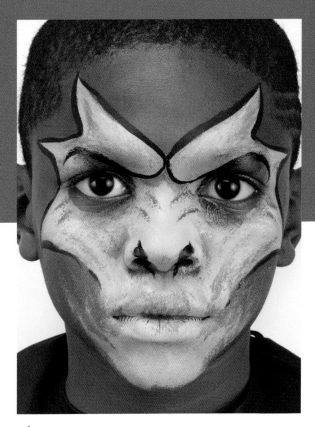

3 Stipple on yellow highlights over the green base with a sponge, then lay in a yellow basecoat around the mouth and chin for the flames coming out of the dragon's nose.

Shade in the eyes with black and a sponge. Use a no. 3 round and black to add the nostrils.

4 Stipple on orange flames over the yellow base using a sponge.

Outline the facial features in black using a no. 3 round.

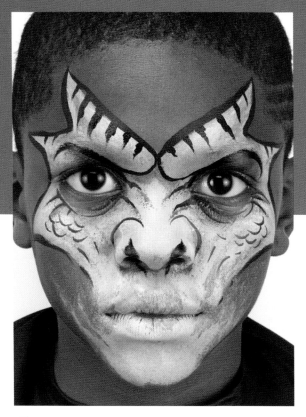

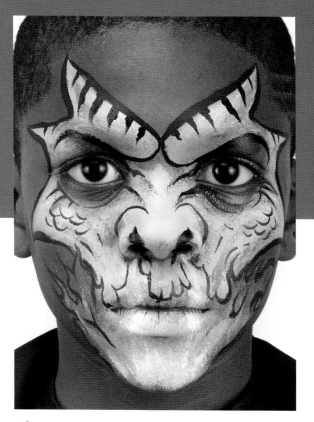

5 Deepen the wrinkles around the eyes and nose, and add scale shapes to the face using a no. 3 round and black. Continue placing details, adding subtle striping at the top of the head.

6 Outline the flames in red using a no. 3 round, then add white highlights to the flames with your brush and sponge.

eXtreme Gargoyle

1 Apply a smooth gray basecoat on the face and ears using a sponge.

2 Shade in the eyes, horns and temples using a sponge and black.

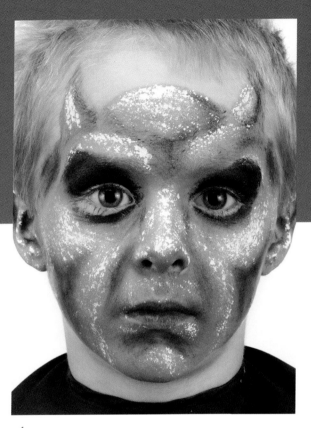

3 Continue developing shadows with a sponge and black, shading in the laugh lines, chin, cheeks, lips and ears.

4 Using a sponge and white, stipple on highlights and add texture, carefully placing color in areas devoid of shadow. Remember, because you want to indicate the texture of stone, it's important that you *not* blend the white marks into the gray basecoat.

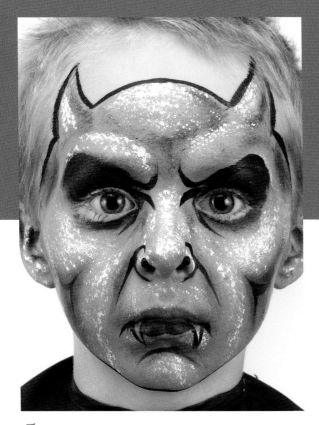 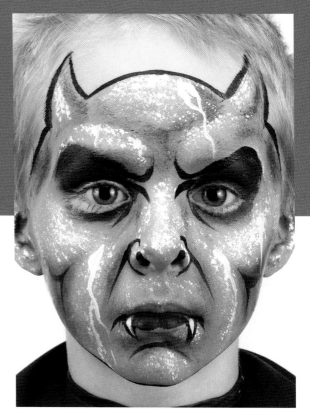

5 Use a no. 3 round and black to outline the face, and define the brows, nostrils and cheeks. Paint the lips and add outlines of teeth using the same brush and color.

6 Fill in the teeth with white using a no. 3 round. Using the same brush, add white drip shapes down the surface of the face, suggesting aged and cracked stone.

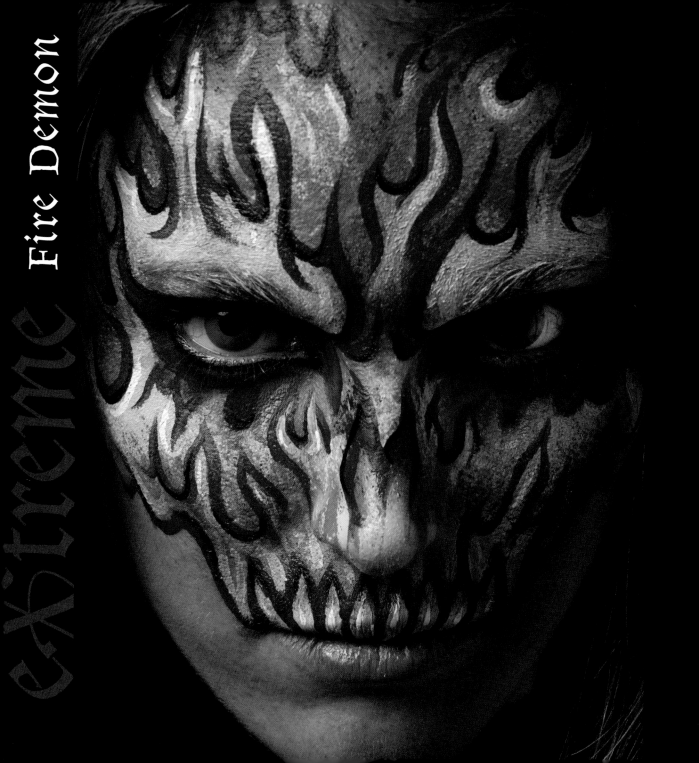

1 Apply a yellow basecoat for the flames with a sponge, stippling on texture as you go.

2 Add orange to the negative spaces around the yellow with a sponge to further develop the flames.

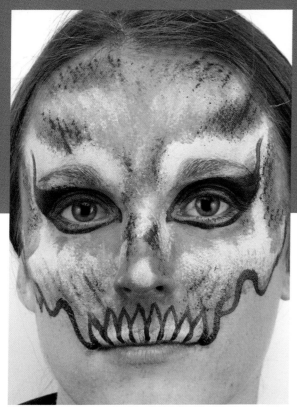 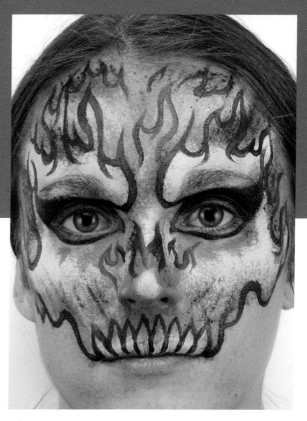

3 Deepen and shape the eyes using a sponge and red. Use red to stipple in more flames along the hairline, on the forehead and temples, and near the mouth. Use a no. 3 round to further exaggerate the shape of the eyes and sharpen the edges of your sponge work. Also add a line under the eyes, and outline the teeth and the bottom edge of the mask with red.

4 Begin detailing the flames, adding red outlines around the eyebrows using a no. 3 round. Add red shading and flame outlines around the nose using the same brush.

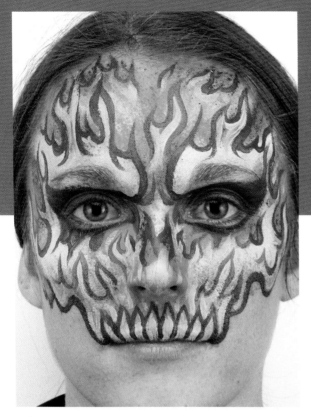 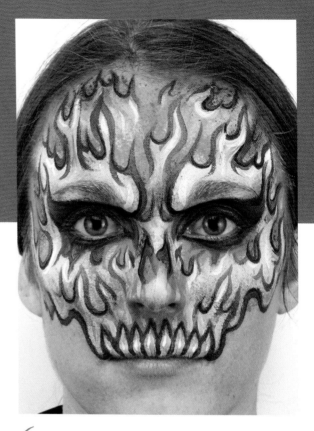

5 Continue to develop the flame shapes on the forehead and cheeks using a no. 3 round and red. With the same brush, add yellow highlights on the flames and fill in the teeth.

6 Line the eyes with black using a no. 3 round, then shadow the center of the flame shapes with thin black lines to deepen the darkest parts of the fire. With the same brush, add a black brow line over the red eye flames, and add white highlights to the brightest yellow areas of the flames and the teeth.

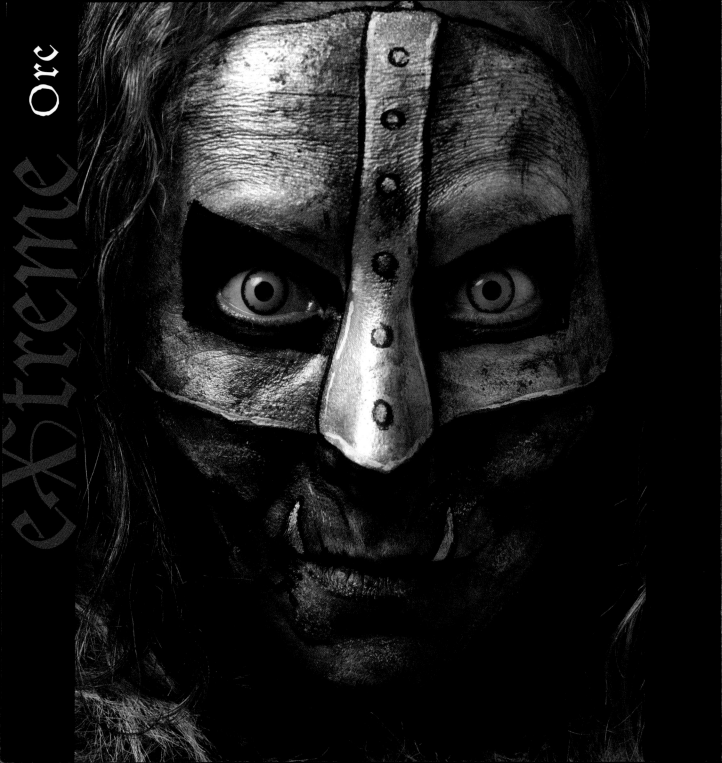

1 Apply the silver helmet shape with a sponge, first stroking on the color and then stippling to fill in the shape. Use a no. 3 round to define the bottom edge of the helmet.

If you'd like colored contacts for added effect (like the model here), have the model put on the lenses before you begin painting to avoid any runs or drips in the makeup.

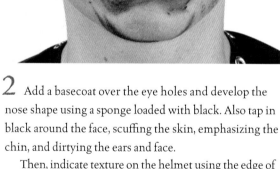

2 Add a basecoat over the eye holes and develop the nose shape using a sponge loaded with black. Also tap in black around the face, scuffing the skin, emphasizing the chin, and dirtying the ears and face.

Then, indicate texture on the helmet using the edge of a sponge dipped in black.

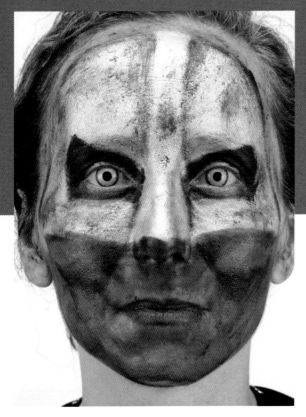

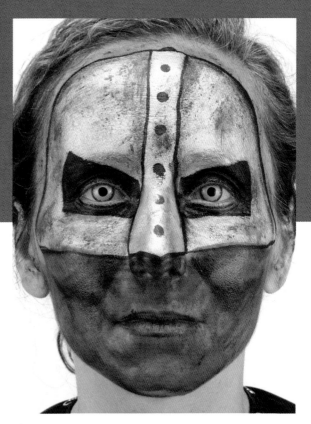

3 Sloppily stipple brown onto the face, smearing it into the black with a sponge. Stipple brown onto the helmet here and there to suggest rust. Go back in with black as needed to redefine the darks, and use a moist towel or tissue to lift color where necessary.

4 Use a cotton swab loaded with black to dab in the circular rivets on the helmet. Then use a no. 3 round to outline the helmet, softening the lines with a cotton swab.

Continue filling in the empty spots around the eyes and cleaning up the face using a no. 3 round and black.

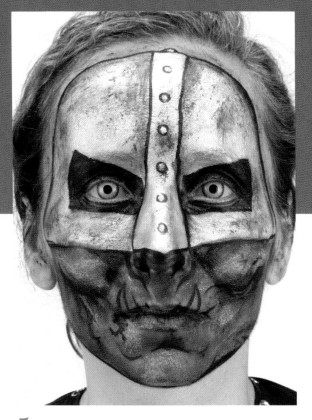

5 Place white highlights on the face using a sponge, and apply white to the rivets with a cotton swab.

Use a no. 3 round loaded with black to outline the jaw, add the teeth and place details on the cheeks and nose. Mottle with the side of the brush to maintain the effect of dirty skin.

6 Color in the teeth and add highlights along the bottom rim of the helmet and bridge guard using a no. 3 round and white.

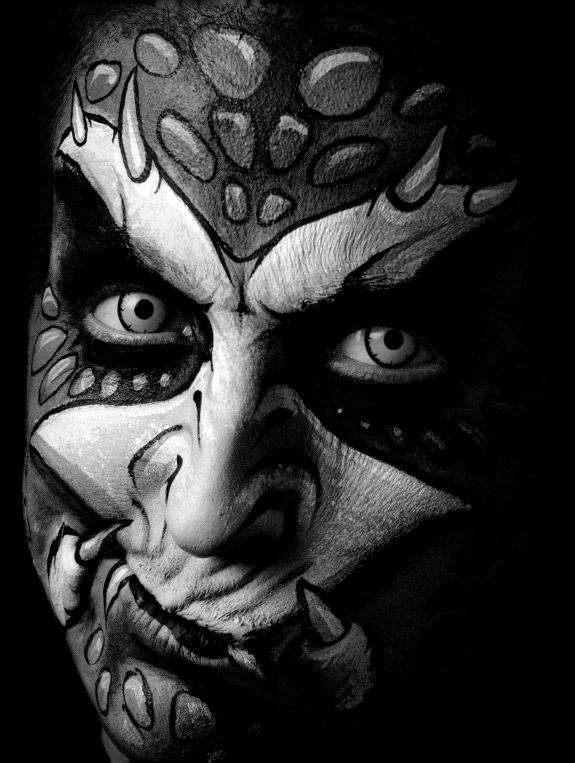

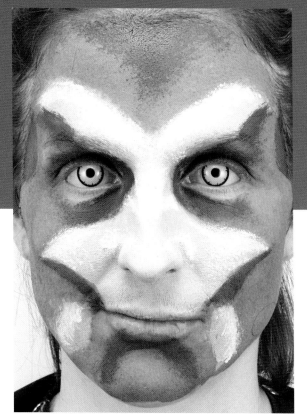

1 Using a sponge, apply a basecoat of pastel blue to the area in the center of the face. Add a neon purple basecoat to the rest of the face.

If you use colored contacts for added effect (like the model here), have the model put the lenses in before you begin painting.

2 Stipple in white highlights on the blue areas using a sponge. Shade in the temples, around the eyes, and beneath the cheek flaps and the chin with a sponge and deep purple.

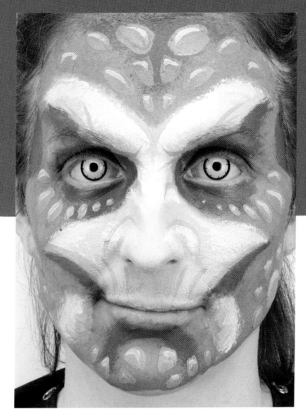

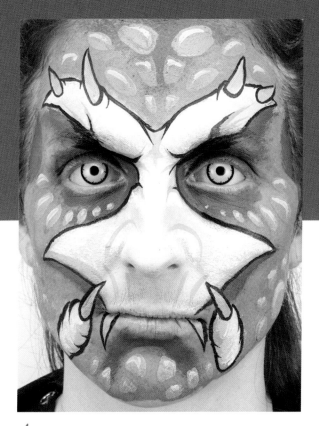

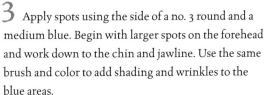

3 Apply spots using the side of a no. 3 round and a medium blue. Begin with larger spots on the forehead and work down to the chin and jawline. Use the same brush and color to add shading and wrinkles to the blue areas.

Use pastel blue and a no. 3 round to add highlights to the spots. Fill in the eye sockets with deep purple using the same brush.

4 Apply goldenrod fangs and horns using a no. 3 round.

Outline the light blue area in the center of the face, working around the fangs and horns and adding wrinkles as your go, using your no. 3 round and black.

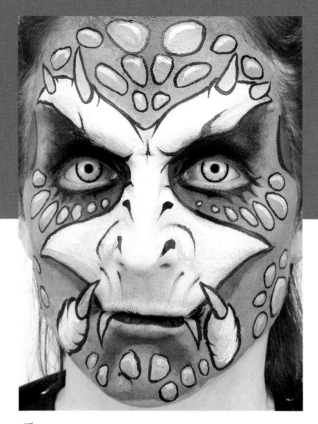

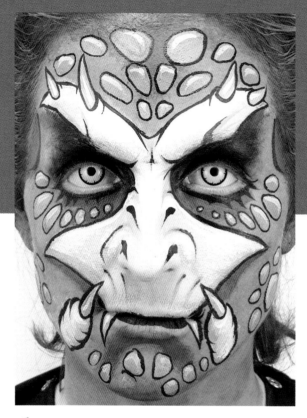

5 Outline the spots with thin black lines using a no. 3 round. Place details around the nose and add lashes beneath the eyes using the same brush and color. Also paint a thin black line between the lips.

Then, using a sponge, apply black on the eyelids to recede the eyes.

6 Using a no. 3 round and white, add highlights to the fangs and horns, and additional linework to the blue center of the face.

Apply deep purple to the neck and ears using a sponge.

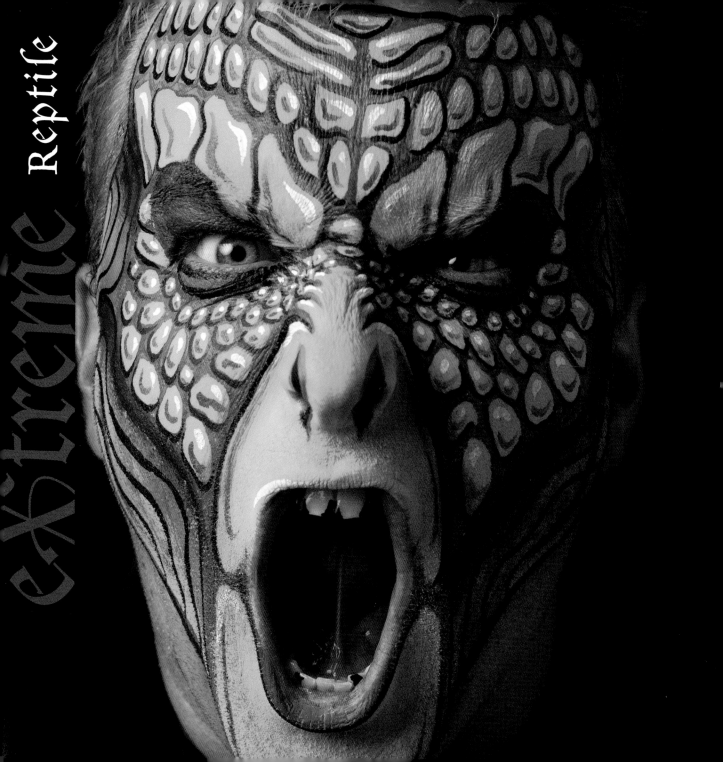

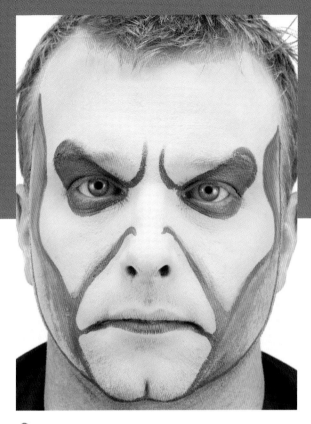

1 Apply a neon green basecoat to the entire face using a sponge.

2 Shadow the eyes and temples with dark green using a sponge, making the face more reptilian. Use a no. 3 round and more dark green to sharpen the edges of the shadows and outline the face, lips, chin and laugh lines.

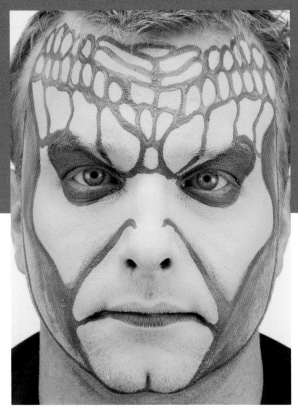

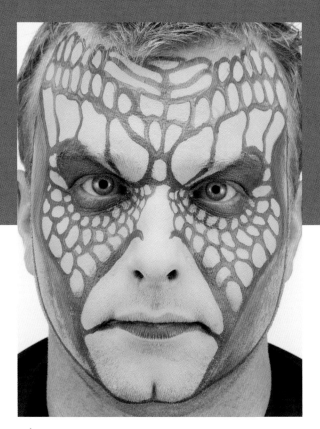

3 Using a no. 3 round and dark green, begin outlining scales on the forehead. Place the largest scales directly on the brow line, making them smaller as you work up toward the hairline. Stagger rows so they don't line up evenly.

4 Using the same brush and color, add smaller scales under the eyes. Follow the eye shape and stagger the scales from row to row so they don't line up.

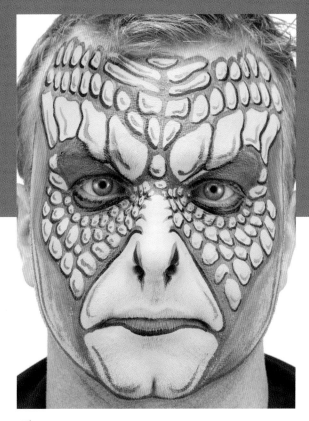 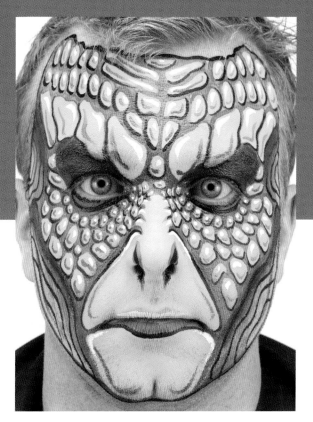

5 Add more scales to the sides of the nose using a no. 3 round and dark green. Add nostril slits and lines around the mouth and chin using the same brush and color. With the same brush, define the facial features, filling in the nostrils and outlining the lips, eyes and laugh lines in black. Add a thin black line under each scale with the same brush.

6 With a no. 3 round and black, outline the face and add wrinkles to the temples and jawline. With the same brush, add white highlights to the top of each scale; place circular shapes on smaller scales and teardrop shapes on larger ones. Add thin white lines around the nose and lower mouth area and on the top lip. Mix dark green with black and apply it to the eyes, the temple and under the cheekbone.

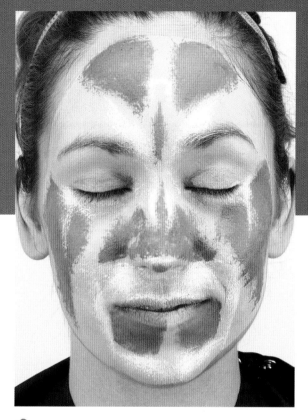

1 Apply a yellow basecoat to the entire face using your sponge.

2 Apply orange faceplates with a sponge, then stipple on white highlights.

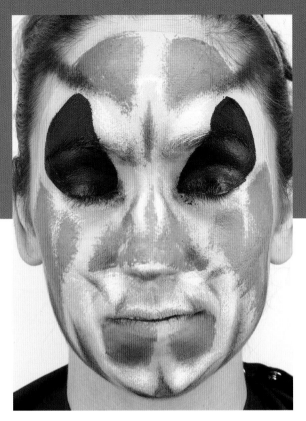

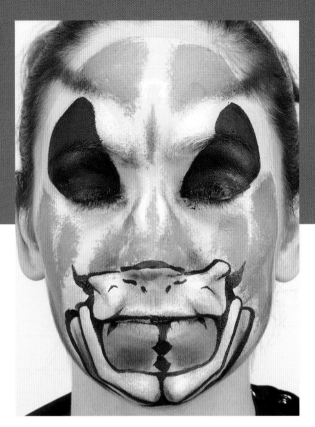

3 Add brown shadowing to the face and suggest the beginnings of a brown antenna on each side of the forehead using a sponge.

Add large black masses over the eyes using a sponge, then outline these shapes with a no. 3 round and black.

4 Add a thin line across the tip of the nose and outline the area between the mouth and nose using a no. 3 round and black. With the same brush and color, outline the lower jaw area and add details around the nose and mouth, using the side of the brush to create wider lines.

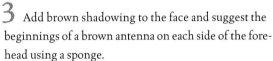

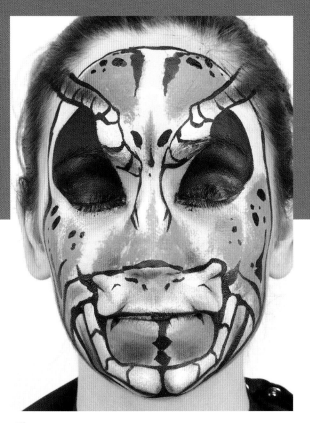 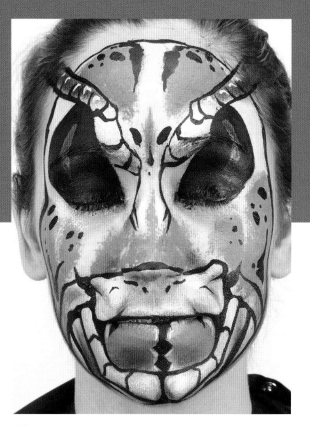

5 Using a no. 3 round and black, add more details around the entire face, paying particular attention to the jaw, forehead and antennae areas.

6 Add white highlights to the antennae and lower mandibles using a no. 3 round. Add purple highlights on the eyes with the same brush, stroking on the color as smoothly as possible.

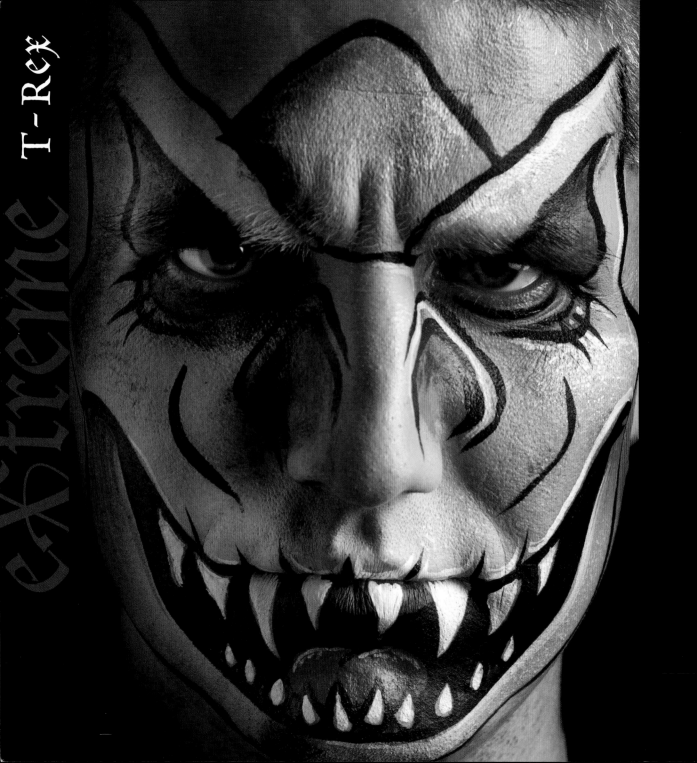

eXtreme T-Rex

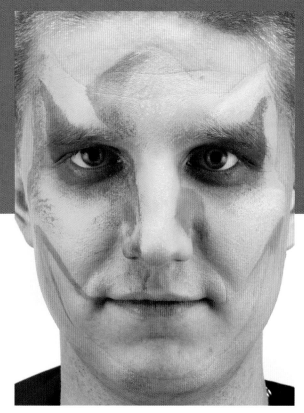

1 Lay in a light green basecoat with a sponge, making sure to paint around what will become the dinosaur's mouth.

2 Add dark green shadowing around the eyes, nose, eyebrow and temple, and along the top jaw using a sponge. Then, stipple yellow highlights on the left side of the face.

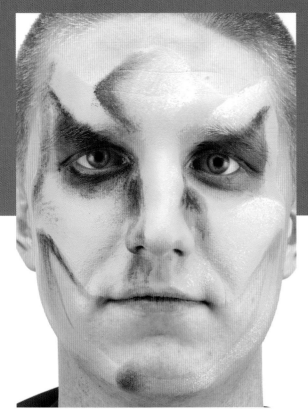

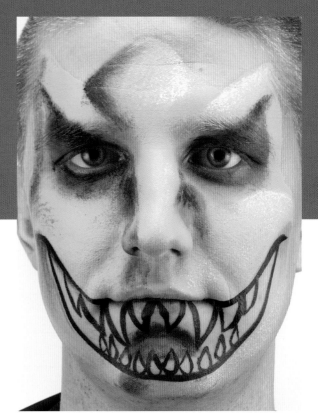

3 With a sponge, stipple white highlights on top of the yellows. Think of it like a sunburn—wherever you get burnt first is where the brightest highlights will be. Also darken the shadows you painted in step 2 by sponging on some black.

4 Sponge a dab of red beneath the lips to suggest the dinosaur's tongue. Then, use a no. 3 round and black to outline the mouth and add outlines of teeth, being careful not to obscure the tongue.

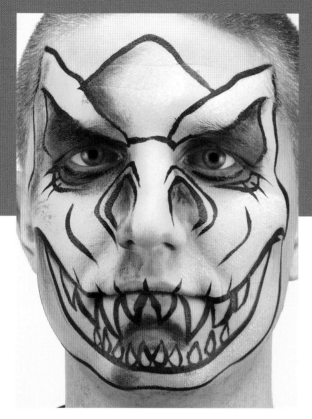

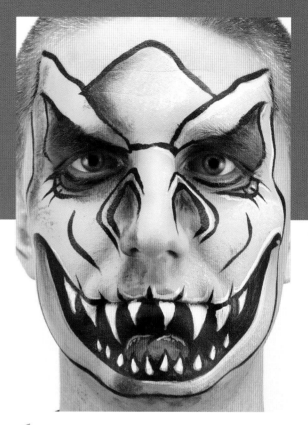

5 Outline the entire face with black using a no. 3 round. Define the eyes and the section of the forehead with the same brush and color. Then, add crow's feet around the eyes and wrinkles on the top lip, and indicate the nostrils beside the nose.

6 Fill in the negative spaces between the teeth with a no. 3 round loaded with black. Shape the tongue as you work. Paint the teeth white, and add white highlights along the top of the tongue with the same brush.

Add white lines around the features on the left side of the face using a no. 3 round to suggest more highlights.

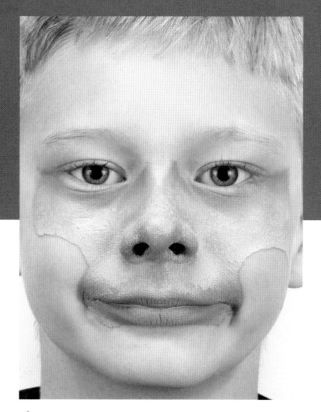

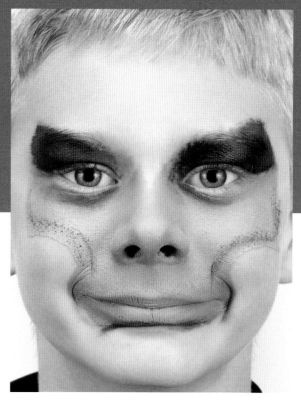

1 Apply a light blue basecoat to the center of the face using a sponge. Start beneath the eyes, cover the nose, mouth and cheekbones, and avoid the jawline and chin.

2 Place shadows around the eyes and along the edges of the cheeks using a sponge and dark blue.

Download a FREE bonus demo at impact-books.com/extreme-costume-makeup.

107

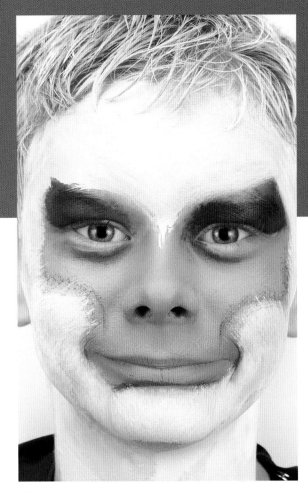

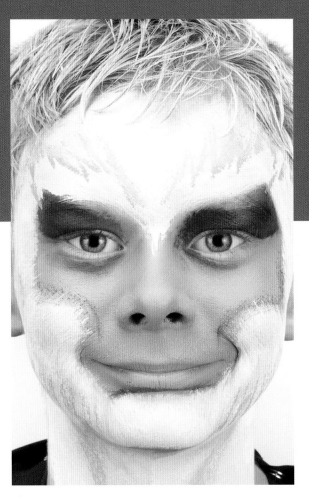

3 Add a white basecoat to the remaining areas of the face, as well as the neck and hair, using a sponge. Gently pull the sponge strokes upward into the blue to create rough edges along the cheeks.

4 Sponge light blue onto the ears, and dab on the outlines of blue fur. Shadow the neck and beneath the chin with the same color.

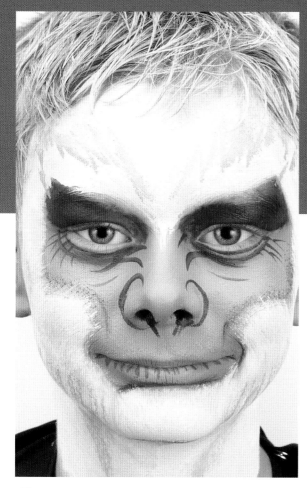 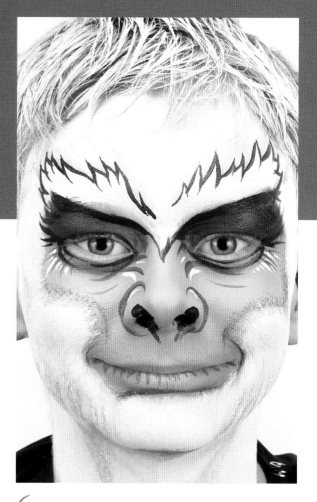

5 Using a no. 3 round and dark blue, add wrinkles around the eyes and nose, plus lines on the lips and slits under the nostrils. Fill in the recessed areas of the ears using the same brush and color.

6 Outline the furry brows, add details around the eyes, and fill in the nostrils using a no. 3 round and black.

Use the same brush to add white highlights on the wrinkles beneath the eyes and on the nose.

Index

About the Authors

Brian and Nick Wolfe have been painting faces professionally for fifteen years. Influenced by comic books, movies, fantasy, fine art and anatomy, they perfected their craft in major theme parks, haunted attractions, fairs and festivals. Now their work appears in books, magazines, television and movies. The twins teach their art at trade shows and conventions and in private homes all around the world. When they are home in Orlando, Florida, they are making costumes, playing heavy metal guitar, singing or partying with friends and family. They are extremely enthusiastic and eagerly share their ideas at eviltwinfx.com.

METRIC CONVERSION CHART

TO CONVERT	TO	MULTIPLY BY
inches	centimeters	2.54
centimeters	inches	0.4
feet	centimeters	30.5
centimeters	feet	0.03
yards	meters	0.9
meters	yards	1.1

Content previously published in *Extreme Face Painting* by Brian & Nick Wolfe.

Other fine IMPACT Books are available from your local bookstore, art supply store or online supplier. Visit our website at fwmedia.com.

17 16 15 14 13 5 4 3 2 1

DISTRIBUTED IN CANADA BY FRASER DIRECT
100 Armstrong Avenue
Georgetown, ON, Canada L7G 5S4
Tel: (905) 877-4411

DISTRIBUTED IN THE U.K. & EUROPE BY F&W MEDIA INTERNATIONAL
Brunel House, Newton Abbot, Devon, TQ12 4PU, England
Tel: (+44) 1626 323200 Fax: (+44) 1626 323319
Email: enquiries@fwmedia.com

DISTRIBUTED IN AUSTRALIA BY CAPRICORN LINK
P.O. Box 704, S. Windsor NSW, 2756 Australia
Tel: (02) 4560 1600, Fax: (02) 4577 5288
Email: books@capricornlink.com.au

ISBN-13: 978-1-4403-2832-9
SRN: U1468

EDITED BY *Jennifer Lepore Brune & Layne Vanover*
PRODUCTION EDITED BY *Stefanie Laufersweiler*
DESIGNED BY *Julie Barnett*
PHOTOGRAPHY BY *Richard Deliantoni & Christine Polomsky*
PRODUCTION COORDINATED BY *Mark Griffin*

Ideas. Instruction. Inspiration.

Download a FREE bonus demo at impact-books.com/Extreme-Costume-Makeup.

Check out these _IMPACT_ titles at impact-books.com!

These and other fine _IMPACT_ products are available at your local art & craft retailer, bookstore or online supplier. Visit our website at impact-books.com.

Follow _IMPACT_ for the latest news, free wallpapers, free demos and chances to win FREE BOOKS!

Follow us!

IMPACT-BOOKS.COM

► Connect with your favorite artists
► Get the latest in comic, fantasy and sci-fi art instruction, tips and techniques
► Be the first to get special deals on the products you need to improve your art